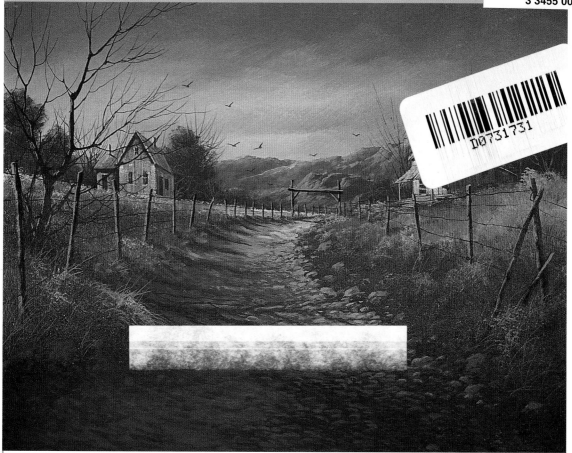

PAINTING

Perspective

NORTH LIGHT BOOKS

CINCINNATI, OHIO
www.artistsnetwork.com

ABOUT THE AUTHOR Jerry Yarnell was born in Tulsa, Oklahoma, in 1953. A recipient of two scholarships from the Philbrook Art Center in Tulsa, Jerry has always had a great passion for nature and has made it a major thematic focus in his painting. He has been rewarded for his dedication with numerous awards, art shows and gallery exhibits across the country. His awards include the prestigious Easel Award from the Governor's Classic Western Art Show in Albuquerque, New Mexico, acceptance in the top 100 artists represented in the national Art for the Parks Competition, an exhibition of work in the Leigh Yawkey Woodson Birds in Art Show, and participation in a premier showing of work by Oil Painters of America at the Prince Gallery in Chicago, Illinois.

Jerry has another unique talent that makes him stand out from the ordinary: He has an intense desire to share his painting ability with others. For years he has taught successful painting workshops and seminars for hundreds of people. Jerry's love for teaching also keeps him very busy offering workshops and private lessons in his new Yarnell Studio & School of Fine Art. Jerry is the author of several books on painting instruction, and his unique style can be viewed on his popular PBS television series, *Jerry Yarnell School of Fine Art*, airing worldwide.

Paint Along With Jerry Yarnell, Volume 7: Painting Perspective. © 2004 by Jerry Yarnell. Manufactured in China. All rights reserved. No part of this book may be reproduced in any form or by any electronic or mechanical means including information storage and retrieval systems without permission in writing from the publisher, except by a reviewer, who may quote brief passages in a review. Published by North Light Books, an imprint of F&W Publications, Inc., 4700 E. Galbraith Road, Cincinnati, Ohio 45236. (800) 289-0963. First edition.

Other fine North Light Books are available from your local bookstore or art supply store or direct from the publisher.

08 07 06 05 04 5 4 3 2 1

Library of Congress Cataloging-in-Publication Data

Yarnell, Jerry.
 Paint Along with Jerry Yarnell.
 p. cm.
 Includes index.
 Contents: v. 7. Painting Perspective
 ISBN 1-58180-379-6 (pbk. : alk. paper)
 1. Acrylic painting—Technique. 2. Landscape painting—Technique. I. Title

ND1535 .Y37 2004
751.4'26—dc21 00-033944
 CIP

Editor: Christina Xenos
Production coordinator: Mark Griffin
Production artist: Anna Lubrecht
Photographer: Scott Yarnell

DEDICATION

It was not difficult to know to whom to dedicate this book. I give God all the praise and glory for my success. He blessed me with the gift of painting and the ability to share this gift with people around the world. He has blessed me with a new life after a very close brush with death. I am here today and able to share all of this with each of you because we have a kind, loving and gracious God. Thank you, God, for all you have done.

Also to my wonderful wife, Joan, who has sacrificed and patiently endured the hardships of an artist's life. I know she must love me or she would not still be with me. I love you, sweetheart, and thank you. Lastly, to my two sons, Justin and Joshua: You both are a true joy in my life.

ACKNOWLEDGMENTS

So many people deserve recognition. First, I want to thank the thousands of students and viewers of my television show for their faithful support over the years. Their numerous requests for instructional materials are really what initiated the process of producing these books. I want to acknowledge my wonderful staff, Diane, Scott and my mother and father for their hard work and dedication. In addition, I want to recognize the North Light staff for their belief in my abilities.

FOR MORE INFORMATION

about the Yarnell Studio & School of Fine Art and to order books, instructional videos and painting supplies contact:

Yarnell Studio & School of Fine Art
P.O. Box 808
Skiatook, OK 74070

Phone: (877) 492-7635

Fax: (918) 396-2846

gallery@yarnellart.com

www.yarnellart.com

METRIC CONVERSION CHART

TO CONVERT	TO	MULTIPLY BY
Inches	Centimeters	2.54
Centimeters	Inches	0.4
Feet	Centimeters	30.5
Centimeters	Feet	0.03
Yards	Meters	0.9
Meters	Yards	1.1
Sq. Inches	Sq. Centimeters	6.45
Sq. Centimeters	Sq. Inches	0.16
Sq. Feet	Sq. Meters	0.09
Sq. Meters	Sq. Feet	10.8
Sq. Yards	Sq. Meters	0.8
Sq. Meters	Sq. Yards	1.2
Pounds	Kilograms	0.45
Kilograms	Pounds	2.2
Ounces	Grams	28.3
Grams	Ounces	0.035

Table of Contents

INTRODUCTION PAGE 6

TERMS & TECHNIQUES PAGE 8

GETTING STARTED PAGE 11

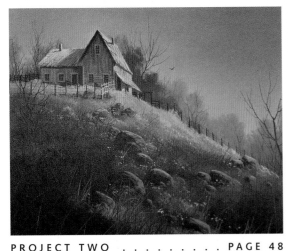

PROJECT ONE. PAGE 36

Country Peace

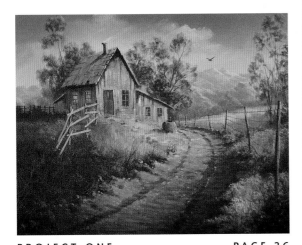

PROJECT TWO PAGE 48

Hilltop Retreat

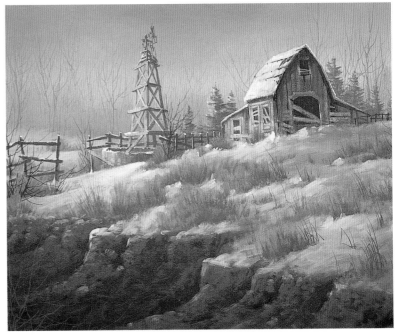

PROJECT THREE PAGE 60

Evening Shadows

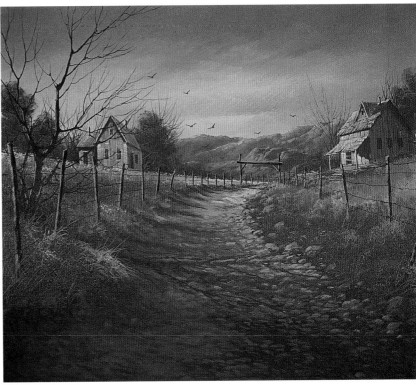

PROJECT FOUR PAGE 74

In Need of Repair

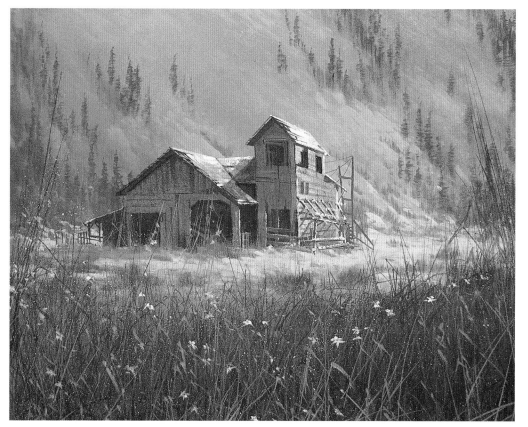

PROJECT FIVE PAGE 88
Lost in Time

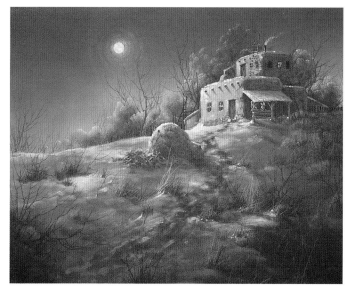

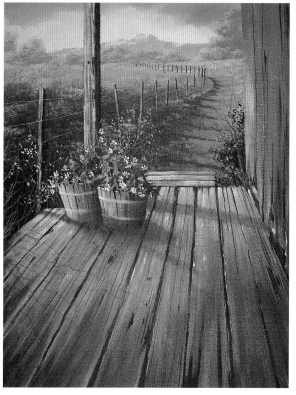

PROJECT SIX PAGE 100
Moonlight Adobe

PROJECT SEVEN PAGE 114
The Front Porch

INDEX. PAGE 126

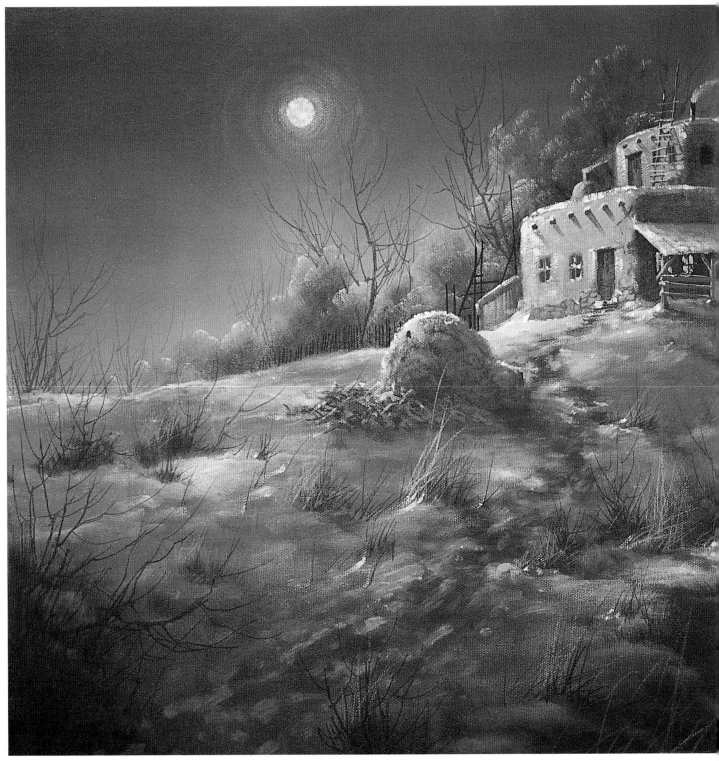

Moonlight Adobe
16" × 20" (41cm × 51cm)

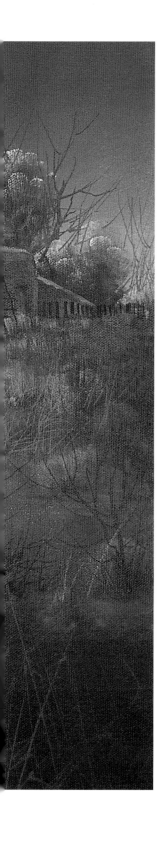

Introduction

Perspective is an important part of a painting's composition. It determines the angle, shape, size and proportion of objects that recede into the distance. Linear perspective is a technique you use to create depth in a painting by making parallel lines meet. Although these lines are not drawn in the painting, they help your mind see the idea of distance.

There are several different and complicated forms of perspective, but landscape artists usually only need to use two basic forms of linear perspective: one-point perspective and two-point perspective.

These two types of perspective establish the proper angles of simple structures, for example, houses, barns and windmills. You also use perspective to create the proper proportion of repetitive objects, such as a row of fence posts, in relation to other objects in the painting. Perspective gives you the height and space between each post. So, you see, perspective is useful. Grab a pencil, ruler and sketch pad and let's go to work!

Terms & Techniques

Before beginning the step-by-step instructions on the following pages, you may want to refresh your memory by reviewing these terms and techniques.

COLOR COMPLEMENTS

Complementary colors always appear opposite each other on the color wheel. Use complements to create color balance in your paintings. It takes practice to understand how to use complements, but a good rule of thumb is to use the complement or form of the complement of the predominant color in your painting to highlight, accent or gray that color.

For example, if your painting has a lot of green, use its complement, red—or a form of red such as orange or red-orange—for highlights. If you have a lot of blue in your painting, use blue's complement, orange—or a form of orange such as yellow-orange or red-orange. The complement of yellow is purple or a form of purple. Keep a color wheel handy until you have memorized the color complements.

DABBING

Use this technique to create leaves, ground cover, flowers, etc. Take a bristle brush and dab it on your table or palette to spread out the ends of the bristles like a fan (see above example). Then load the brush with the appropriate color and gently dab on that color to create the desired effect.

DOUBLE LOAD OR TRIPLE LOAD

To load a brush this way, put two or more colors on different parts of

To prepare your bristle brush for dabbing, spread out the ends of the bristles like a fan.

your brush. Mix these colors on the canvas instead of your palette. Double or triple load your brush for wet-on-wet techniques.

DRYBRUSH

Load your brush with very little paint and lightly skim the surface of the canvas with a very light touch to add, blend or soften a color.

EYE FLOW

Create good eye flow and guide the viewer's eye through the painting with the arrangement of objects on your canvas or the use of negative space around or within an object. The eye must move smoothly, or flow, through your painting and around objects. The viewer's eyes

shouldn't bounce or jump from place to place. Once you understand the basic components of composition—design, negative space, "eye-stoppers," overlap, etc.—your paintings will naturally achieve good eye flow.

FEATHERING

Use this technique to blend, to create soft edges, to highlight and to glaze. Use a very light touch, barely skimming the surface of the canvas with your brush.

GESSO

Gesso is a white paint used for sealing canvas before painting on it. Because of its creamy consistency and because it blends so easily, I often use gesso instead of white paint.

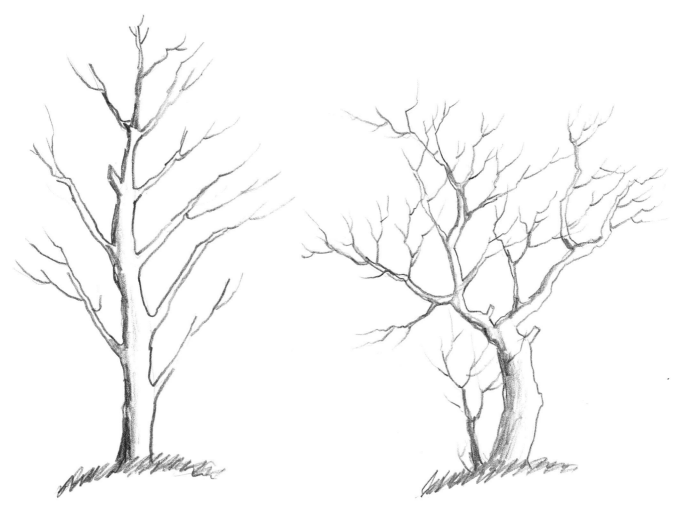

This sketch uses poor negative space. The limbs don't overlap each other, but are evenly spaced so there are few pockets of interesting space.

This sketch uses negative space well. The limbs overlap and include interesting pockets of space.

When I use the word gesso in my step-by-step instructions, I am referring to the color white. Use gesso or whatever white pigment you prefer.

GLAZE (WASH)
A glaze or a wash is a very thin layer of paint applied over a dry area to create mist, fog, haze or sun rays or to soften an area that is too bright. Dilute a small amount of color with water and apply it to the appropriate area. You can apply the glaze in layers, but each layer must be dry before applying the next.

HIGHLIGHTING OR ACCENTING
Highlighting is one of the final stages of your painting. Use pure color or brighter values to give your painting its final glow. Carefully apply highlights on the sunlit edges of the most prominent objects in your paintings.

MIXING
If you will be using a mixture often, premix a good amount of that color to have handy. I usually mix colors with my brush, but sometimes a palette knife works better. Be your own judge.

I also sometimes mix colors on my canvas. For instance, when I am underpainting grass, I may put two or three colors on the canvas and scumble them together to create a mottled background of different colors. This method also works well for skies.

When working with acrylics, always mix your paint to a creamy consistency that will blend easily.

NEGATIVE SPACE
Negative space surrounds an object to define its form and create good eye flow (see above example).

SCRUBBING

Scrubbing is similar to scumbling, but the strokes should be more uniform and in horizontal or vertical patterns. Use a dry-brush or wet-on-wet technique with this procedure. I often use it to underpaint or block in an area.

SCUMBLING

Use a series of unorganized, overlapping strokes in different directions to create effects such as clumps of foliage, clouds, hair, grass, etc. The direction of the stroke is not important for this technique.

UNDERPAINTING AND BLOCKING IN

The first step in all paintings is to block in or underpaint the dark values. You'll apply lighter values of each color to define each object later.

VALUE

Value is the relative lightness or darkness of a color. To achieve depth or distance, use lighter values in the background and darker values closer to the foreground. Lighten a color by adding white. Make a value darker by adding black, brown or the color's complement.

WET-ON-DRY

I use this technique most often in acrylic painting. After the background color is dry, apply the topcoat by drybrushing, scumbling or glazing.

WET-ON-WET

Blend the colors together while the first application of paint is still wet. I use a large hake (pronounced ha-KAY) brush to blend large areas, such as skies and water, with the wet-on-wet technique.

Make the value of a color lighter by adding white.

Getting Started

Acrylic Paint

The most common criticism of acrylics is that they dry too fast. Acrylics do dry very quickly because of evaporation. To solve this problem I use a wet palette system (see pages 13-15). I also use very specific dry-brush blending techniques to make blending very easy. With a little practice you can overcome any of the drying problems acrylics pose.

Speaking as a professional artist, I believe acrylics are ideally suited for exhibiting and shipping. You actually can frame and ship an acrylic painting thirty minutes after you finish it. You can apply varnish over an acrylic painting, but you don't have to because acrylic painting is self-sealing. Acrylics are also very versatile because you can apply thick or creamy paint to resemble oil paint or paint thinned with water for watercolor techniques. Acrylics are nontoxic with very little odor, and few people have allergic reactions to them.

USING A LIMITED PALETTE

I work from a limited palette. Whether for professional or instructional pieces, a limited palette of the proper colors is the most effective painting tool. It teaches you to mix a wide range of shades and values of color, which every artist must be able to do. Second, a limited palette eliminates the need to purchase dozens of different colors.

With a basic understanding of the color wheel, the complementary color system and values, you can mix thousands of colors for every type of painting from a limited palette.

For example, mix Thalo Yellow-Green, Alizarin Crimson and a touch of Titanium White (gesso) to create a beautiful basic flesh tone. Add a few other colors to the mix to create earth tones for landscape paintings. Make black by mixing Ultramarine Blue with equal amounts of Dioxazine Purple and Burnt Sienna or Burnt Umber. The list goes on and on, and you'll see that the sky isn't even the limit.

Most paint companies make three grades of paints: economy, student and professional. Professional grades are more expensive but much more effective. Just buy what you can afford and have fun. Check your local art supply store first. If you can't find a particular item, I carry a complete line of professional- and student-grade paints and brushes (see page 3).

MATERIALS LIST

Palette

white gesso
Grumbacher, Liquitex or Winsor & Newton paints (color names may vary):

 Alizarin Crimson

 Burnt Sienna

 Burnt Umber

 Cadmium Orange

 Cadmium Red Light

 Cadmium Yellow Light

 Dioxazine Purple

 Hooker's Green Hue

 Phthalo (Thalo) Yellow-Green

 Titanium White

 Ultramarine Blue

Brushes

no. 4 flat sable brush

no. 4 round sable brush

no. 4 script liner brush

no. 4. flat bristle brush

no. 6 flat bristle brush

no. 10 flat bristle brush

2-inch (51mm) hake brush

Miscellaneous Items

16" × 20" (41cm × 51cm) stretched canvas

charcoal pencil

easel

no. 2 soft vine charcoal

palette knife

paper towels

Sta-Wet palette

spray bottle

Brushes

I use a limited number of brushes for the same reasons as the limited palette—versatility and economy.

2-INCH (51MM) HAKE BRUSH

Use this large brush for blending, glazing and painting large areas, such as skies and bodies of water with a wet-on-wet technique.

NO. 10 FLAT BRISTLE BRUSH

Underpaint large areas—mountains, rocks, ground or grass—and dab on tree leaves and other foliage with this brush. It also works great for scumbling and scrubbing techniques. The stiff bristles are very durable so you can treat them fairly roughly.

NO. 6 FLAT BRISTLE BRUSH

Use this brush, a cousin of the no. 10 flat bristle brush, for many of the same techniques and procedures. The no. 6 flat bristle brush is more versatile than the no. 10 because you can use it for smaller areas, intermediate details and highlights. You'll use the no. 6 and no. 10 flat bristle brushes most often.

NO. 4 FLAT SABLE BRUSH

Use sable brushes for more refined blending, details and highlights, such as final details, painting people and adding details to birds and other animals. Treat these brushes with extra care because they are more fragile and more expensive than bristle brushes.

NO. 4 ROUND SABLE BRUSH

Use this brush, like the no. 4 flat sable, for details and highlights. The sharp point of the round sable, though, allows more control over areas where a flat brush will not work or is too wide. This is a great brush for finishing a painting.

NO. 4 SCRIPT LINER BRUSH

This brush is my favorite. Use it for very fine details and narrow linework, such as tree limbs, wire, weeds and especially your signature, that you can't accomplish with any other brush. Roll the brush in an ink-like mixture of pigment until the bristles form a fine point.

BRUSH-CLEANING TIPS

As soon as you finish your painting, use quality brush soap and warm water to clean your brushes thoroughly before the paint dries. Lay your brushes flat to dry. Paint is very difficult to get out if you allow it to dry on your brushes or clothes. If this does happen, use denatured alcohol to soften the dried paint. Soak the brush in the alcohol for about thirty minutes and then wash it with soap and water.

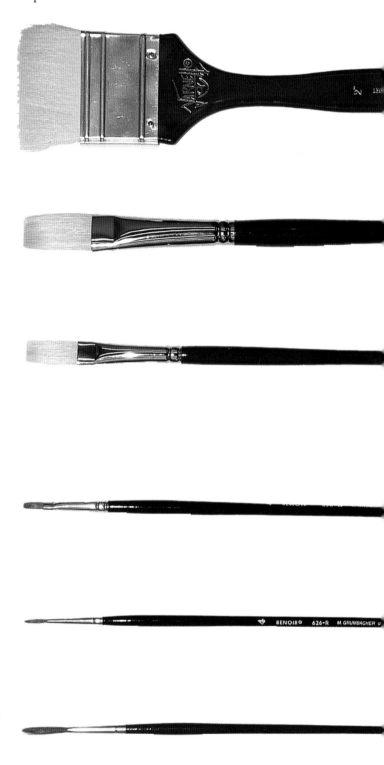

You can make any subject with this basic set of brushes.

Palettes

Several palettes on the market are designed to keep paints wet. I use two Sta-Wet palettes made by Masterson. Acrylics dry because of evaporation, so keeping the paints wet is critical. The first palette is a 12" × 16" (31cm × 41cm) plastic palette-saver box with an airtight lid (see page 14). Saturate the sponge that comes with the palette with water and lay it in the bottom of the box. Then soak the special palette paper and lay it over the sponge. Place your paints around the edges and you are ready to go. Use a spray bottle to mist your paints occasionally so they will stay wet all day long. When you are finished painting, attach the lid and your paint will stay wet for days.

My favorite palette is the same palette with a few alterations (see page 15). Instead of the sponge and special paper, I place a piece of double-strength glass in the bottom of the palette. I fold paper towels into quarters to make long strips, saturate them with water and lay them on the outer edges of the glass. I then place my paints on the paper towels. They stay wet for days. I occasionally mist them to keep the towels wet.

If you leave your paints in a sealed palette for several days without opening it, certain colors, such as Hooker's Green Hue and Burnt Umber, will mildew. Just replace the color or add a few drops of chlorine bleach to the water in the palette to help prevent mildew.

To clean the glass palette, allow it to sit in water for about thirty seconds or spray the glass with your spray bottle. Scrape off the old paint with a single-edge razor blade.

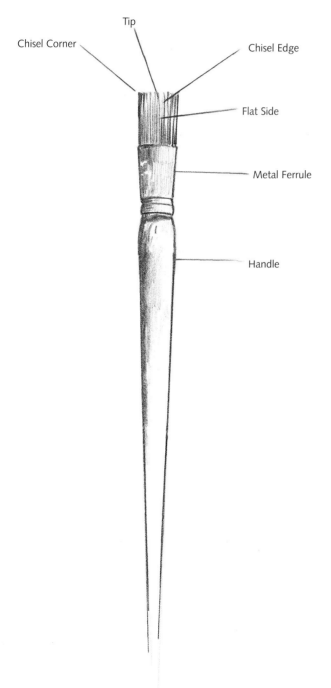

Tip

Chisel Corner

Chisel Edge

Flat Side

Metal Ferrule

Handle

Two Ways to Set Up Your Palette

The Sta-Wet 12" × 16" (31cm × 41cm) plastic palette-saver box comes with a large sponge that you saturate with water.

Lay the sponge inside the palette box, soak the special palette paper and lay it over the sponge. Place your paints around the edges. Don't forget to mist them to keep them wet.

When closing the palette-saver box, make sure the airtight lid is on securely. When the palette is properly sealed, your paints will stay wet for days.

Instead of using the sponge and palette paper, you can use a piece of double-strength glass in the bottom of the palette. Fold paper towels in long strips and saturate them with water.

Lay the saturated paper towels around the outer edges of the glass.

Place your paints on the paper towel strips.

Use the center of the palette for mixing paints. Occasionally spray a mist over the paper towels to keep them wet.

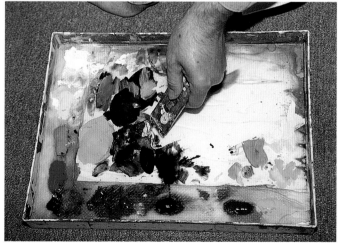

To clean the palette, allow it to sit for thirty seconds in water or spray the glass with a spray bottle. Scrape off the old paint with a single-edge razor blade.

Miscellaneous Supplies

CANVAS

Canvas boards work for practicing strokes, and canvas paper pads work for studies or testing paints and brush techniques. The best surface for painting, though, is a primed, pre-stretched cotton canvas with a medium texture, which you can find at most art stores. As your skills advance, you may want to learn to stretch your own canvas, but 16" × 20" (41cm × 51cm) pre-stretched cotton canvases are all you'll need for the paintings in this book.

EASEL

I prefer a sturdy, standing easel. My favorite is the Stanrite ST500 aluminum easel. It is lightweight, sturdy and easy to fold up to take on location or to workshops.

LIGHTING

Of course, the best light is natural north light, but most of us don't have this light in our work areas. The next best lighting option is to hang 4' (1.2m) or 8' (2.4m) fluorescent lights directly over your easel. Place one cool bulb and one warm bulb in the fixture to best simulate natural light.

Studio lights

16" × 20" (41cm × 51cm) stretched canvas

Stanrite aluminum studio easel

SPRAY BOTTLE

I use a spray bottle with a fine mist to lightly wet my paints and brushes throughout the painting process. I recommend a spray bottle from a beauty supply store. It's important to keep one handy.

PALETTE KNIFE

I use my palette knife more for mixing than for painting. A trowel-shaped knife is more comfortable and easier to use than a flat knife.

SOFT VINE CHARCOAL

I use no. 2 soft vine charcoal for most of my sketching. It's very easy to work with, shows up well and is easy to remove with a damp paper towel.

Spray bottle

Soft vine charcoal

Palette knives

Elements of Perspective

We use the following terms when we discuss perspective. Learn these terms before you get started.

1. *One-point perspective*—Use this to determine angle, height and proportion of an object only on one side.

2. *Two-point perspective*—Use this when you are trying to determine the proper angle, height and proportion of an object on two sides.

3. *Horizon line*—This is the line where the land and the sky meet. You place the vanishing point or points on this line. Your vanishing lines meet this line to determine the perspective of an object.

4. *Vanishing point*—This is the point you place at a specified location on the horizon line. All vanishing lines meet on this point. You may need one or two points depending on the type of perspective you use.

5. *Vanishing lines*—Draw these lines from the corners of an object back to the vanishing point on the horizon line. The lines help determine the length, height and proportion of an object.

6. *Parallel lines*—All lines correspond in equal direction. These lines don't determine an object's perspective, but prevent an object from appearing that it is falling over.

You need the following supplies to practice one-and two-point perspective techniques.

- 12" (30cm) ruler or a 36" (91cm) yard stick, whichever you prefer
- 12" × 16" (30cm × 41cm) or larger sketchpad
- No. 2B or no. 4B sketching pencil
- Kneaded eraser or gum eraser

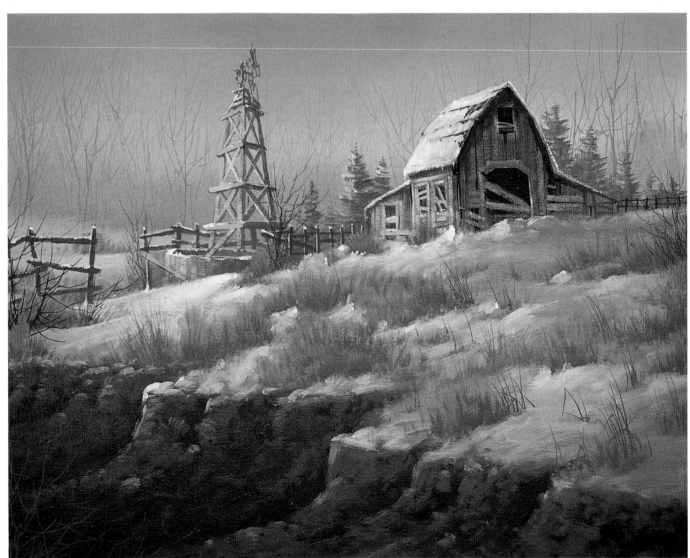

In Need Of Repair
16" x 20" (41cm x 51cm)

Viewing Perspective

These sketches give you a visual understanding of the basic terms used when discussing perspective. Study these illustrations and draw your own before you begin an in-depth study.

It will be well worth your time and energy to experiment with all the different possibilities that perspective gives you. It may seem very challenging at first, but with patience, you will be amazed how even the most basic understanding of perspective will enhance your paintings with the addition of buildings and other objects to your landscapes that have perfect perspective.

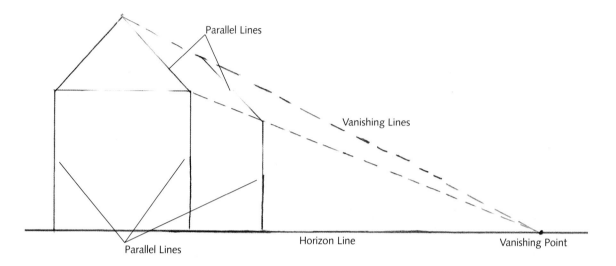

Parallel Lines

Vanishing Lines

Parallel Lines

Horizon Line

Vanishing Point

DETERMINE THE VANISHING POINT IN ONE-POINT PERSPECTIVE

Here, all the vanishing lines meet at one vanishing point. In one-point perspective, always place the vanishing point on the side of the object where you are determining perspective.

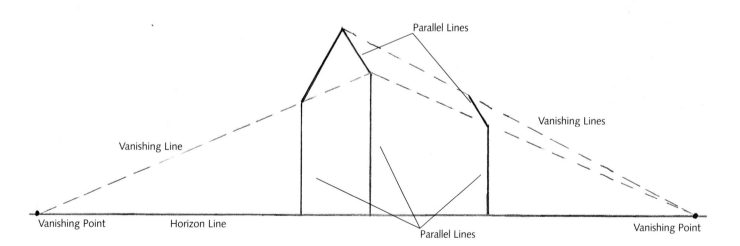

Parallel Lines

Vanishing Lines

Vanishing Line

Vanishing Point

Horizon Line

Parallel Lines

Vanishing Point

TWO-POINT PERSPECTIVE DETERMINES PROPER ANGLES

Use two-point perspective to determine the proper angle, height and proportion of an object. Notice that each of the building's horizontal lines recede to its vanishing point.

Drawing One-Point Perspective

In one-point perspective you only determine perspective on one side of the building. Notice the vanishing point is on the right side of the box.

Where you place the vanishing point on the horizon line depends on what degree you want your angle. The closer the vanishing point is to the box, the larger the angle you will have. The farther away the vanishing point is from the box, the smaller the angle.

1 Place the Box
Draw a box on the horizon line. Place the vanishing point on the horizon line. Shift it to the right of the center. Now determine the perspective of the box's right side.

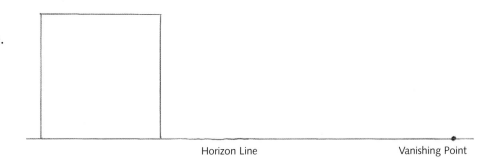

Horizon Line Vanishing Point

2 Construct Perspective
Draw a vanishing line from the upper-right corner of the box to the vanishing point.

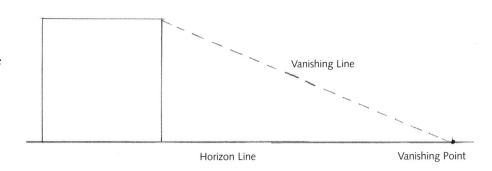

Vanishing Line

Horizon Line Vanishing Point

3 Finish Perspective
Decide the box length by drawing a vertical line between the vanishing line and the horizon line making it parallel to the right side of the box.

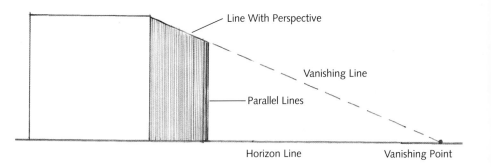

Line With Perspective

Vanishing Line

Parallel Lines

Horizon Line Vanishing Point

Sizing Dramatic Angles

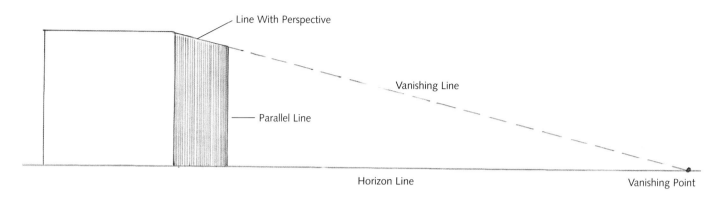

Line With Perspective

Vanishing Line

Parallel Line

Horizon Line

Vanishing Point

REDUCE DRAMATIC ANGLE

Move the vanishing point farther away from its object to lessen the angle. Here, the vanishing point is far to the right, giving the building a gradual angle.

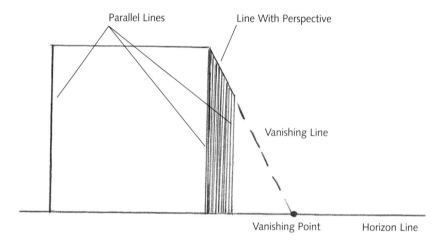

Parallel Lines

Line With Perspective

Vanishing Line

Vanishing Point

Horizon Line

INCREASE DRAMATIC ANGLE

Move the vanishing point closer to the box to give it a sharp and dramatic angle.

Placing the Vanishing Point

Choose the location of the vanishing point on the horizon line depending on what kind of angles you need. The following examples illustrate some other variations. The sky is the limit, so experiment with different locations of horizon lines and vanishing points.

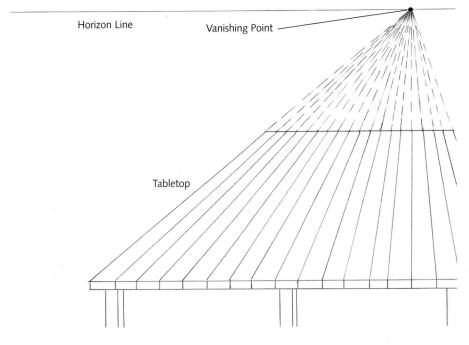

EXPERIMENT WITH VANISHING POINT LOCATIONS

Notice that I placed the vanishing point on the horizon line slightly to the right of the center of the table. By placing the horizon line high above the back of the table, you create the illusion of looking down on the table, which makes it appear shorter. If you move the horizon line and the vanishing point much closer to the back of the table, it would appear much longer, as if you were viewing it at eye level. There are many combinations so give them a try.

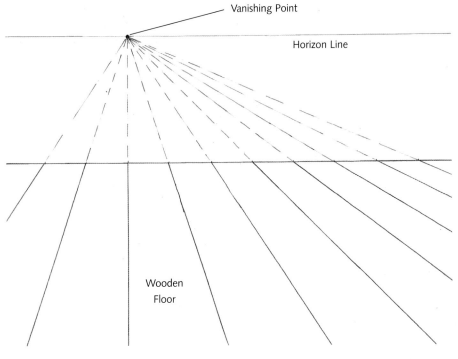

DETERMINE VANTAGE POINT THEN PLACE VANISHING POINT

The location of the horizon line and vanishing point gives you different effects. This example is drawn from the perspective of sitting in a chair looking across the wooden floor. To find the proper perspective for a subject, first determine if you are standing, sitting or lying down. Then place the horizon line and vanishing point accordingly.

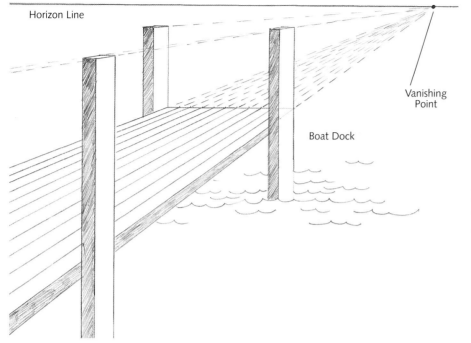

Horizon Line

Vanishing Point

Boat Dock

DEFINE ANGLES WITH HORIZON LINE AND VANISHING POINT

In this example of the boat dock, notice that the dock is shifted far to the left and angled toward the center of the drawing. This leads the viewer's eye into the center of the drawing where I may add other objects as focal points. Also notice the dock is elevated above the water so you can see the posts above and below the dock. By painting the vanishing point far to the right, I created a defined angle. By painting the horizon line high above the dock, I created a vantage point as though I were standing on the ground looking toward the dock.

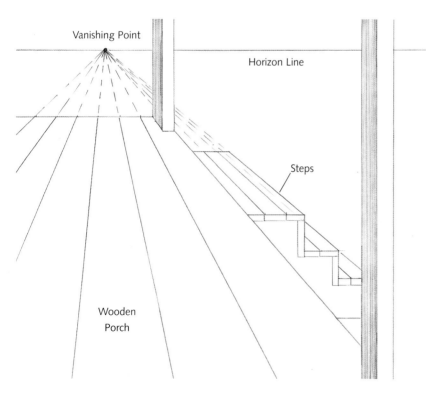

Vanishing Point

Horizon Line

Steps

Wooden Porch

CREATE STEPS USING PERSPECTIVE

This example shows a front porch—very similar to the wooden floor except I added steps connected to the porch. The important aspect to remember when drawing these steps is to draw a horizontal line out from the porch for the top of the first step then draw a vertical line for the height of the riser. Repeat this for the next step back to the vanishing point. Now decide the length you want the step and draw a horizontal parallel line to the front of the step.

Applying Perspective

These are four steps you must complete before beginning your project.
1. Draw the horizon line. You can put it high on the page, toward the bottom or anywhere in between.
2. Place your vanishing point anywhere on the horizon line.
3. Sketch your object on the horizon line, above it or below it.
4. Size the building.

Remember, the choices you make decide the outcome of your project. For example, if you determine the perspective of a house on a hillside, the house will be set above the horizon line; if you were on a hillside looking down at a house, the house would be below the horizon. If you were on a flat plane, the house would be either on the horizon or slightly above or below it.

DETERMINING PERSPECTIVE ON THE LEFT SIDE OF A SHAPE
In the previous examples you saw a box with perspective on the right side. Now let's see what it looks like on the left side. Draw the box anywhere you want on the horizon line. Follow the basic procedure for creating perspective by adding the vanishing point, vanishing lines and the vertical parallel line at the end of the box to establish its length.

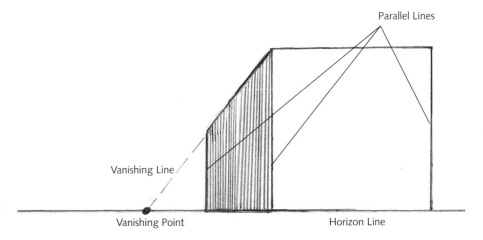

CREATING DIFFERENT LENGTHS
Move this line anywhere between the vanishing line and the horizon line to create different lengths. Notice I moved the end vertical line on the left side farther out to make the box longer.

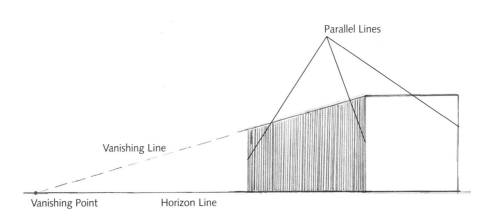

Perspective Above the Horizon

Try determining the perspective of a box above the horizon. You use this technique to create a subject sitting on top of a hill as you stand at the base of the hill looking up at your subject.

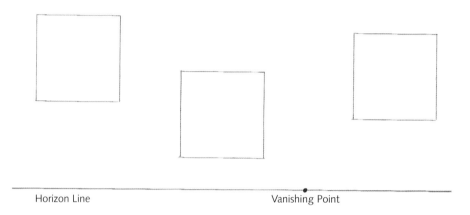

Horizon Line Vanishing Point

1 Draw Boxes Above Horizon Line
Place three boxes in different locations above the horizon line. These boxes could represent houses sitting on a hill. Place the vanishing point anywhere along the horizon line.

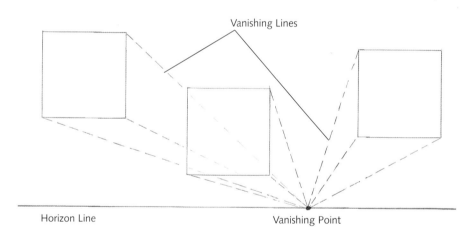

Vanishing Lines

Horizon Line Vanishing Point

2 Draw Vanishing Lines
Draw vanishing lines from the corners of the boxes to the vanishing point.

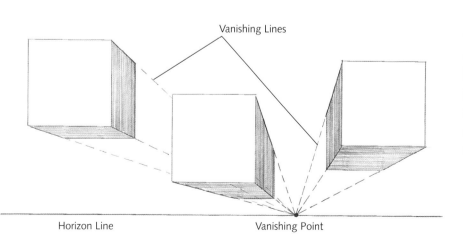

Vanishing Lines

Horizon Line Vanishing Point

3 Determine Box Length
Decide how long you want each box. Draw parallel lines to form the final shape of the box. Keep in mind that once you place the landscape elements, you won't see the bottom of the house as you see it here.

Creating Perspective Possibilities

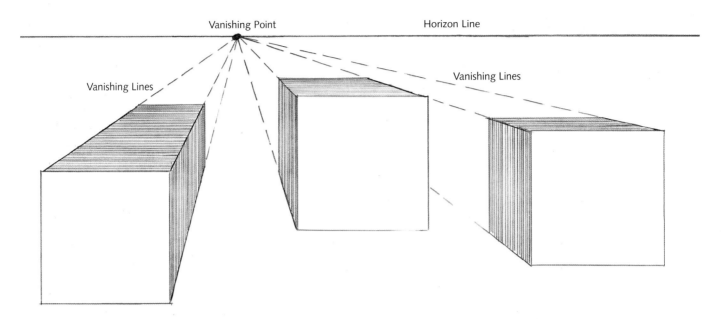

FIND PERSPECTIVE BELOW HORIZON LINE

If you are standing on a hill looking down on a house, your boxes will be placed below the horizon line. Put the boxes anywhere you want under the horizon line. Connect all corners to the vanishing point with vanishing lines. Decide the length of each box and draw the opposite horizontal or vertical parallel lines.

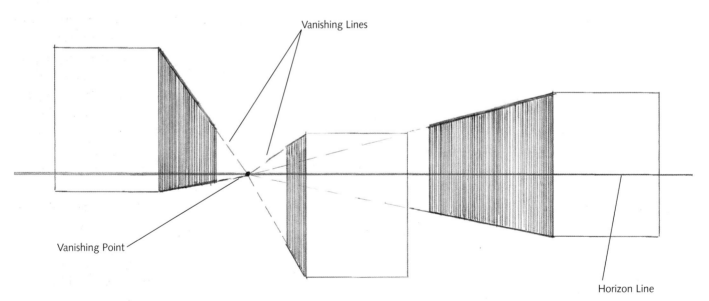

DETERMINE PERSPECTIVE COMBINATIONS

Another possibility is placing the boxes so they are partially above and partially below the horizon line. The vanishing point can be placed anywhere on the horizon line depending on what angle you want. Connect each corner to the vanishing point with a vanishing line. Create the length of each box by drawing in the parallel lines.

Drawing Multiple Perspectives

Now let's look at another perspective possibility. Imagine walking down a road or pathway with rows of houses on each side. The problem with perspective here is that you need to determine the perspective of the right side of the buildings on the left side of the painting and the left side of the buildings on the right side of the painting. Accommodating this scenario may sound confusing, but it's really quite simple.

1 Establish Horizon Line
First establish the horizon line. Place the vanishing point somewhere toward the center. Draw the front of two buildings.

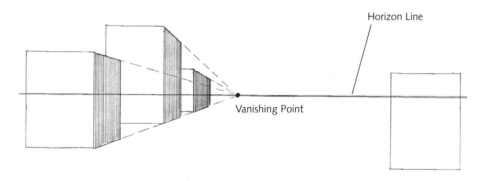

2 Create Multiple Buildings
Determine the perspective on the right side of the building by drawing the vanishing line from the corners to the vanishing point. Draw the vertical parallel line to determine the building's length. Draw another box behind the first one and repeat the perspective process. Draw as many buildings as you want. Remember to always draw the front of each building first, then determine the perspective of their sides. For a balanced composition, make each building a slightly different shape or height.

3 Finish Perspective
Repeat this process on the right side of the vanishing point. Remember, you can space the buildings as far apart as you want and shift them to the left or to the right. Just make sure you have determined the perspective for all the sides so they lead back to the vanishing point.

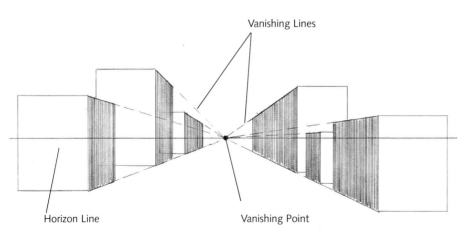

Finding Perspective of a House

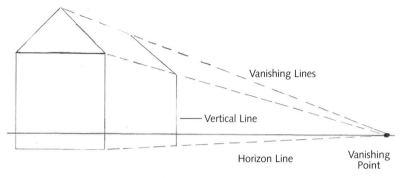

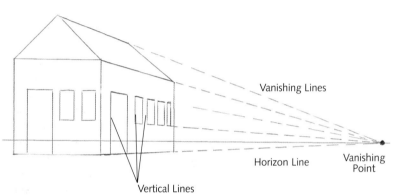

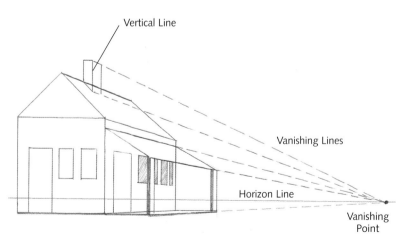

DRAW A ROOF

Locate the horizon line. Locate the front of your house and draw a rectangle. Locate the vanishing point on the right side of the box. Draw the vanishing lines from all corners to the vanishing point. Draw a vertical line between the vanishing lines for the length. For the roof, place a point at the center of the building above the top line at the height where you want your roof. Draw lines from the point down to the corners of the building's front. Draw a vanishing line from the roof down to the vanishing point. For the correct angle of the back roofline, draw a line between the the vanishing lines. Make this exactly parallel with the front roofline.

ADD DOORS AND WINDOWS

Repeat the above steps to construct a house. Draw doors and windows on the front of the building. Make them parallel with each other. Find their perspective beginning from the farthest window or door from the vanishing point—in this case, the door. Draw one vertical parallel line at the height you want the door. Draw a vanishing line back to the vanishing point. Now, determine the door's width by drawing a vertical parallel line between vanishing lines. Determine the number, size and location of windows. Draw a vertical line from the existing vanishing line the length you want the window. Draw a vanishing line from the bottom of the window to the vanishing point. Add more windows by finding the location of each one and drawing vertical lines between the vanishing lines. Remember, as objects recede into the distance, they get closer together and smaller.

ADD CHIMNEY AND PORCH

Complete the house in the above example. Determine the chimney's location. Draw the front of the chimney. From the top of the chimney, draw a vanishing line to the vanishing point. Repeat for the bottom of the chimney. Decide the chimney's width and draw a vertical line between the vanishing lines. For the porch roof, draw the front roof line at any angle and length. Then draw a vanishing line from the end of the roofline to the vanishing point. This establishes the proper angle for the front of the roof. For the end of the roof, draw a parallel line to the front roofline from the house's corner to the vanishing line. Now the roof has perspective. Repeat this procedure for the porch floor. Then add the posts.

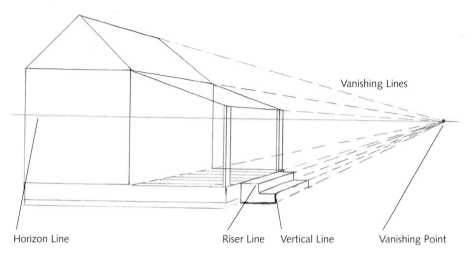

Vanishing Lines

Horizon Line · Riser Line · Vertical Line · Vanishing Point

DRAW STEPS

Draw the riser line for the top step. Determine depth. Draw a line from the bottom of the riser to the vanishing point. Decide length of steps. Draw the back vertical riser line. Draw a horizontal line establishing width of the top of the step. Draw a line from the top step's corner to the vanishing point. You have the first step's angle. Determine the number of additional steps and repeat this procedure for each one.

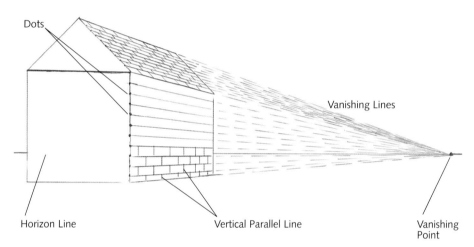

Dots

Vanishing Lines

Horizon Line · Vertical Parallel Line · Vanishing Point

DRAW SHINGLES, SIDING, BRICKS

Decide how far apart each row of shingles should be. Place a row of dots on the front of the roof for which you have not determined the perspective. Draw vanishing lines to the vanishing point. Draw vertical lines to establish shingle length. Use the same procedure for wood siding. Place a row of dots spaced apart at the desired length. Draw a vanishing line from each dot to the vanishing point. Repeat the siding procedure for the bricks. Then draw vertical parallel lines establishing each brick's length.

Drawing Perspective from a Photo

After you have seen some technical aspects of creating perspective, a question almost always emerges: How do I know where to start with the perspective process from an existing photograph of a house or building for which I am trying to determine the perspective? Let's look at the following example to answer this question.

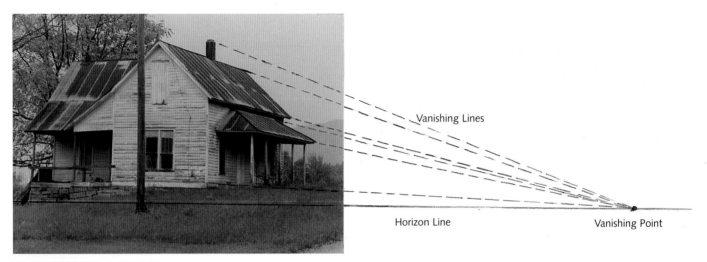

Vanishing Lines

Horizon Line

Vanishing Point

TRANSFERRING A PHOTO

Take a photo and lay it on a piece of paper that is several inches larger than the photo. Take a piece of tracing paper and lay it over the entire surface. Draw lines with a ruler following all of the angles of the house that have perspective. All of these lines meet each other at the vanishing point. After locating the vanishing point, draw a horizontal line parallel to the top and bottom of the paper, across the paper through the vanishing point. This will be your horizon line. Now transfer this on a larger scale to your canvas with the vanishing point and horizon line. Begin adding any other objects.

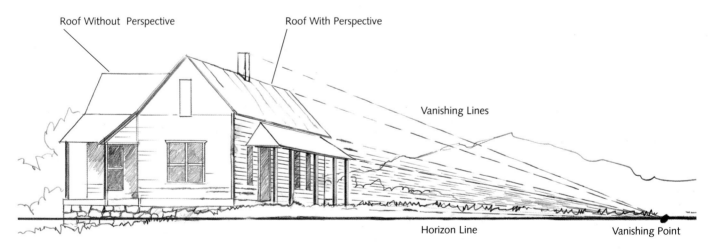

Roof Without Perspective

Roof With Perspective

Vanishing Lines

Horizon Line

Vanishing Point

REVIEW STEPS

Listed below are all steps you need to complete the drawing. Locate the horizon line. Locate the vanishing point. Draw the front of the house. Draw roof on the side that doesn't need perspective. Add perspective to the top of the roof. Add perspective to the bottom of the roof. Add perspective to the bottom of the house. Draw parallel lines to establish the house's length. Draw windows and doors on the front of the house. Add perspective to doors and windows. Add perspective to the chimney and shingles. Add perspective to the porch roof. Add perspective to the siding. Add horizontal posts. Draw the landscape.

Drawing Perspective for a Still life

Not only is perspective useful for the landscape painter, but also still life, portrait and figure painters often need to find the perspective for a wooden table, floor or other interior objects. We won't spend much time here, but I think a short discussion and an example will be helpful for some of you who like to work with still lifes.

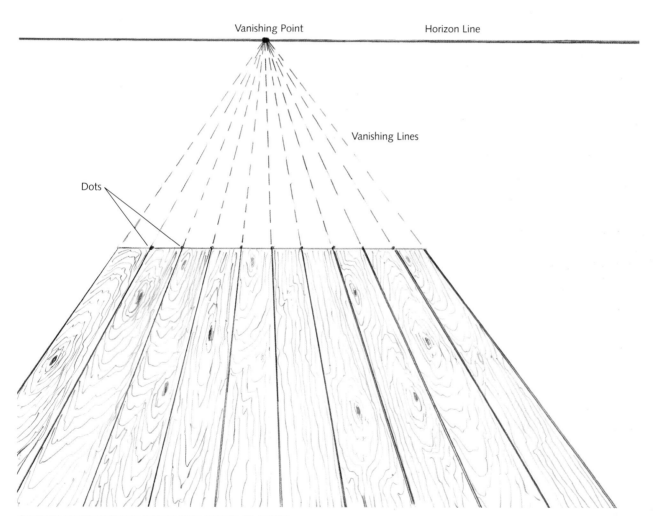

Vanishing Point Horizon Line

Vanishing Lines

Dots

CREATE PERSPECTIVE WITH WOODEN PLANKS
Determine the perspective for a wooden tabletop or floor on which you are going to place a vase of flowers or bowl of fruit. Establish the location of the table by drawing its horizontal back edge. Decide the angle of the wooden planks. Locate the vanishing point based on the angle of the boards. Place dots along the back horizontal edge of the table spaced at whatever intervals you wish. Draw vanishing lines through the dots back to the vanishing point and then to the front of the table. Now you have a tabletop with proper perspective.

Drawing Two-Point Perspective

After learning one-point perspective principles you can now concentrate on two-point perspective. All of the same rules that you used in one-point perspective apply in two-point perspective. The only difference is that you need two vanishing points instead of one. In two-point perspective, you are finding the perspective of two sides of the building. Let's look at an example of a simple object with two-point perspective.

1 Draw Building
Only draw the front corner of the building, which is a vertical line placed above, below or on the horizon line. In this drawing, I chose to place it slightly below the horizon line.

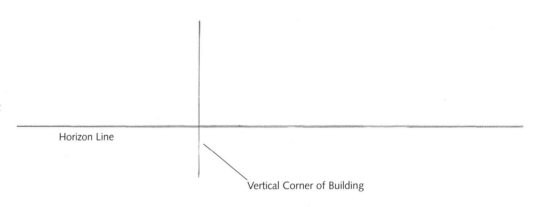

Horizon Line

Vertical Corner of Building

2 Determine Vanishing Points
Once you've placed the building's corner line, place the two vanishing points, one on each side of the corner line. The vanishing point locations depend on the size of the angles you want the sides of the building to have.

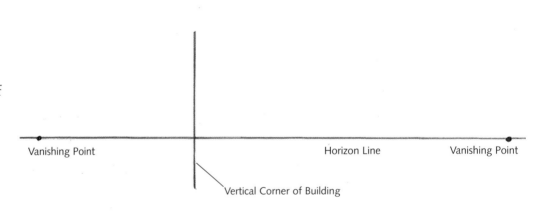

Vanishing Point

Horizon Line

Vanishing Point

Vertical Corner of Building

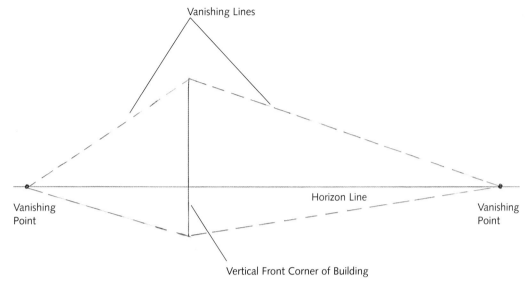

Vanishing Lines

Vanishing
Point

Horizon Line

Vanishing
Point

Vertical Front Corner of Building

3 Connect Vanishing Lines

Draw vanishing lines from the top and bottom of the corner line back to the vanishing points. This gives you the proper perspective of the sides.

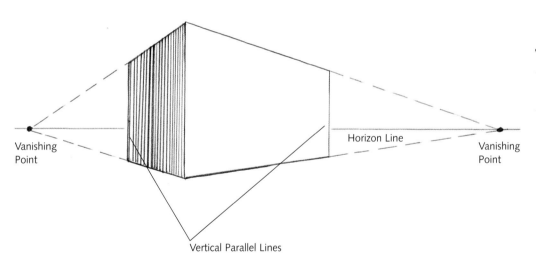

Vanishing
Point

Horizon Line

Vanishing
Point

Vertical Parallel Lines

4 Determine Length

Decide how long you want each side to be, then draw vertical lines between the vanishing lines at that length.

Using Two-Point Perspective

In this example you are going to find the perspective of the building, roof, doors, windows and sidewalk. The process for finding the perspective of these two sides is identical to the process used in one-point perspective. Instead of going all the way through that process again, simply refer back to these basic steps if you get confused. The next illustration is a fairly simple house with two-point perspective. The only different aspect is a sidewalk on each side of the house. The process of finding the perspective of a house is described on page 28.

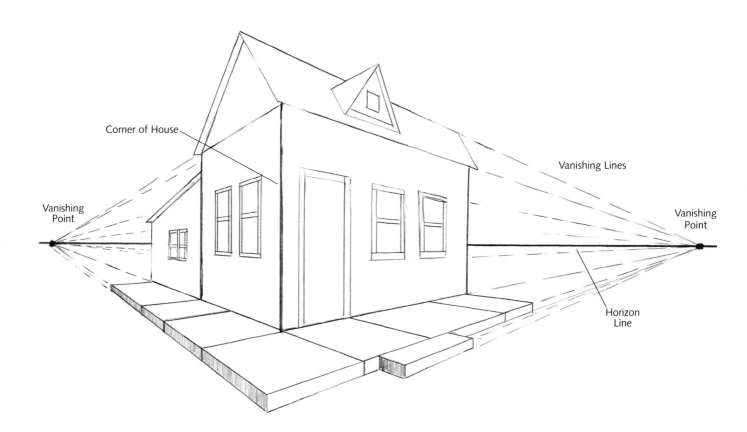

Corner of House

Vanishing Point

Vanishing Lines

Vanishing Point

Horizon Line

DRAWING A HOUSE

Find the corner of the house. Draw the horizon line, vanishing points and vanishing lines. Find the perspective of both sides. Add vertical lines to create the length of the house. Draw the roof on the left side of building. Find the perspective for the roof on the right side. Add parallel lines for the end of the roof. Find the perspective of the door. Find the perspective of the windows. Add the back porch. Add the dormer. Find the perspective of the steps. Find the perspective of the sidewalk, just extend the lines at the base of the house out as far as you want to go. From the end of each line, draw vanishing lines back to the vanishing points. This gives you the proper length and angle for the end of the sidewalk. Draw the perspective for each sidewalk section back to the opposite vanishing point.

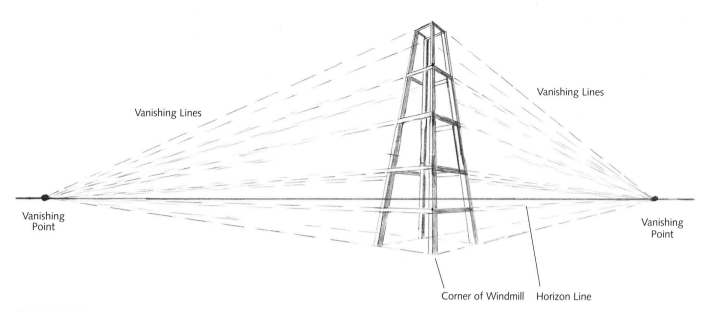

Vanishing Lines

Vanishing Lines

Vanishing
Point

Vanishing
Point

Corner of Windmill Horizon Line

DRAW WINDMILL

Let's find the perspective of an old windmill. Locate the horizon line. Locate the corner of
the windmill. Locate the vanishing points. Draw the vanishing lines back to the vanishing
points. Because this windmill has three sides instead of four, you must determine the
angle of the two legs and draw them. Be certain they stay within the vanishing lines. To
find the perspective of the braces, simply decide the number and the distance apart, then
place dots on the front leg. Draw the vanishing lines back to the vanishing points. Locate
the back leg. For the back braces, draw vanishing lines from the point where the side
braces intersect the legs, back to their opposite vanishing points.

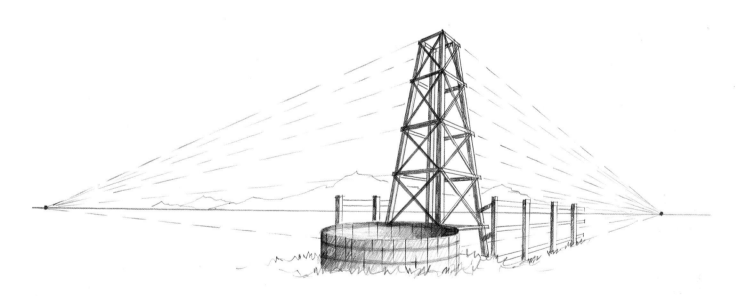

ENHANCING WITH PERSPECTIVE

Begin adding the details around the windmill to give it character. This is the completed
sketch after all the vanishing lines have been erased and details added. I added crossbrac-
ing, landscaping, a water tank and other miscellaneous objects. Some of these items don't
have perspective. However, since the fence recedes into the distance and is on the right
side of the windmill, it will need to have perspective. Draw in the fence post that is next
to the windmill. Then draw a vanishing line from the top of the post back to the vanish-
ing point. Now draw each post. Make sure each one stays between the vanishing lines
and ground. Notice how each post gets smaller and closer to the adjacent post.

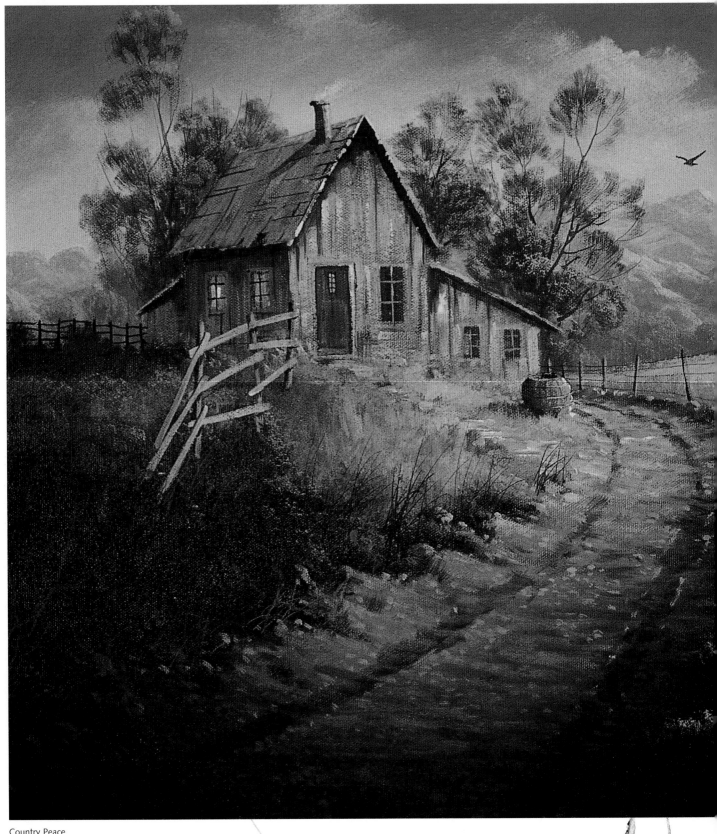

Country Peace
16" × 20" (41cm × 51cm)

Country Peace

This should be a fairly easy one-point perspective project. I placed this house closer to the foreground so it fills up most of the canvas. There is no doubt this old farmhouse is the center of interest. In Oklahoma, we have a wealth of great old farmhouses. You might have some of these near your home. They make great artistic perspective studies. I recommend driving around in your area and photographing old homes from different vantage points. Position yourself on level ground, on a hill looking down or in a valley looking up at the house. All of these positions give you many options to find the perspective of the house. In this case, I chose to stand in front of the house, shifted slightly right of center—meaning you can only see perspective on the left side of the house. This shouldn't give you too much trouble, but if you need help, refer back to the front of the book for some helpful tips. Good luck!

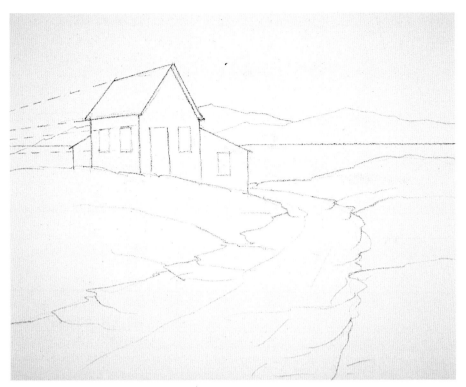

1 Sketch a Farmhouse

In this one-point perspective project, the vanishing point is off the canvas. It is helpful to put an extension of cardboard or paper beyond the canvas to draw the horizon line and place the vanishing point. This is a common problem when you find the perspective for large close-up objects. Take your no. 2 soft vine charcoal and make a sketch of the farmhouse and landscape.

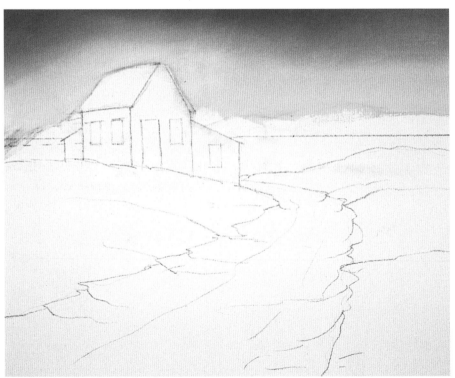

2 Paint Sky

To create the cheerful sky, mix gesso with Ultramarine Blue and a slight touch of Dioxazine Purple on your palette. Lightly wet the sky with a hake brush and apply a fairly liberal coat of gesso. While the gesso is still wet, paint a small amount of Cadmium Yellow Light at the horizon line and blend about halfway up. Begin blending the sky blue mixture down from the top of the sky until the light blue and light yellow mixtures are blended together. You should have a seamless blend between the two mixtures. Feather with crisscross strokes to achieve the best blend.

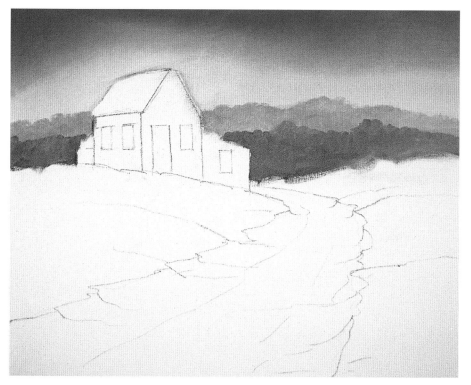

3 Paint Background Hills

Mix gesso with a touch of Burnt Sienna, Dioxazine Purple and Ultramarine Blue, creating a very soft gray. It may be slightly on the purple side. The farthest layer needs to be slightly darker than the horizon. Paint in some irregularly shaped hills or mountains with a no. 6 bristle brush. Darken the same mixture by one or two shades with a touch more Ultramarine Blue, Burnt Sienna and Dioxazine Purple. Paint the layer of mountains closest to the house with a no. 6 bristle brush. Keep in mind that these mountains have one purpose—to create depth. Keep them simple so they don't compete with the house.

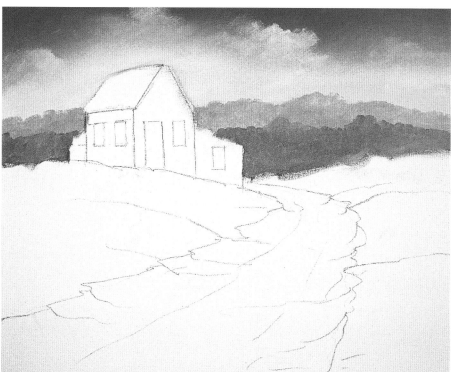

4 Add Clouds

This is a fairly simple step. Create a creamy mixture of gesso with a slight touch of Cadmium Yellow Light to just tint the gesso. Load a very small amount of the mixture onto a no. 6 bristle brush. Gently scrub in some very soft, wispy clouds. These are not a feature and should not compete with the rest of the painting. Keep them simple and soft.

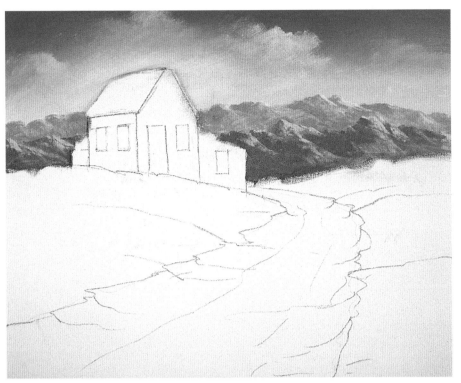

5 Highlight Background Hills

For this basic step you need a soft highlight color of gesso with a touch of Cadmium Yellow Light and Cadmium Orange. Use either a no. 4 flat sable brush or a no. 4 flat bristle brush to scrub in some soft highlights. Highlight the distant hills first and then darken the mixture slightly with Cadmium Orange. Highlight the front mountain range and be sure the highlights just lightly suggest rugged mountains so they don't distract the viewer's eye from the center of interest.

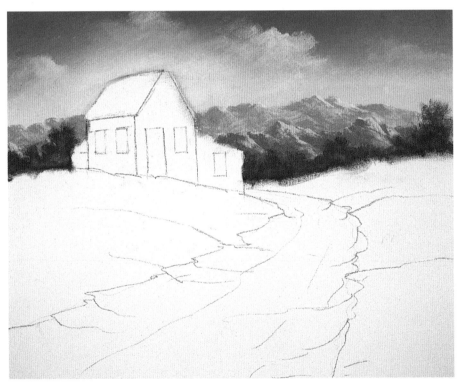

6 Underpaint Background Trees

Mix Hooker's Green Hue with a touch of Dioxazine Purple and gesso to make a very soft grayish-green. This value should be only slightly darker than the last range of hills. Add a group of trees in front of the mountain range using a no. 6 or no. 4 bristle brush. Be sure these trees don't become too big. They are just filler between the background and the middle ground.

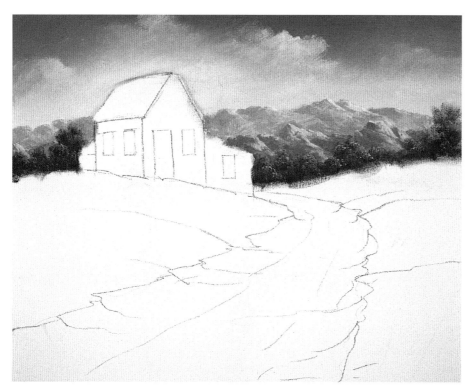

7 Highlight Background Trees

For this quick step, mix Thalo Yellow-Green with a touch of Cadmium Orange and gesso. The mixture should be soft and light. Paint the highlights on the top right side of each clump of trees with a no. 6 bristle brush. Don't over highlight. Paint just enough to give them a basic form.

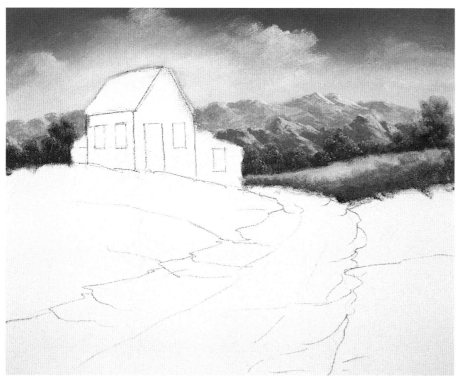

8 Underpaint Background Meadow

Mix Thalo Yellow-Green with a touch of gesso. Apply the color fairly thick in the area in front of the trees. Then quickly add a small amount of Hooker's Green Hue with a touch of Dioxazine Purple at the base. While the mixture is still wet, scrub up the lighter color first with a no. 10 bristle brush. Follow with the darker color and then scrub it up into the lighter color. You have just created a light and medium value to set a subtle contrast in the middle background. You don't need much texture here.

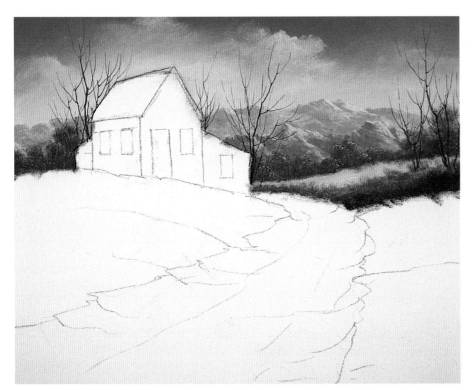

9 Add Background Tree Trunks and Resketch House

Locate the house. Mix Burnt Sienna with a touch of Ultramarine Blue. Lighten the value with a touch of gesso. Add enough water to create a very thin ink-like mixture. Paint in tree trunks with a no. 4 script liner brush, keeping them fairly thin and delicate. Remember, you will add leaves to them later. Resketch the house if you have painted over it.

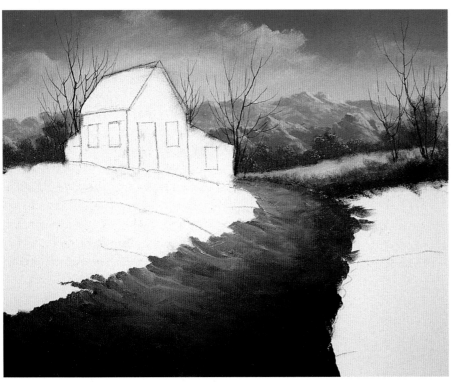

10 Underpaint Road

The road is underpainted with a combination of Burnt Sienna mixed with touches of Dioxazine Purple and gesso. Mix these colors on the canvas instead of the palette using a no. 10 bristle brush. Starting at the back of the road, apply gesso with touches of Burnt Sienna. Use short, choppy horizontal strokes. As you come forward, add more Burnt Sienna and touches of Dioxazine Purple. Continue adding more Burnt Sienna and Dioxazine Purple until you have a fairly dark foreground. Notice the road is darker on the right side, with a choppy texture.

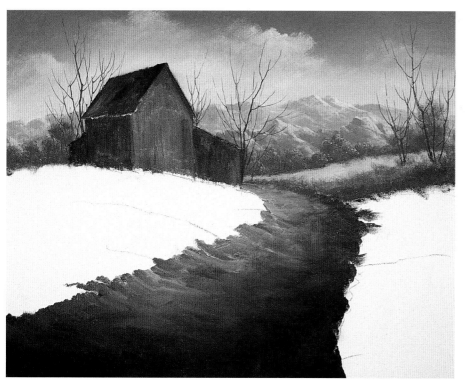

11 Underpaint House

Create a grayish mixture of Burnt Sienna, Ultramarine Blue and gesso. Then use a no. 4 bristle brush and block in the dark side of the house first. Slightly lighten the mixture with a small amount of gesso, and block in the roof. Now lighten the mixture more and block in the front of the house. Clean up the house by straightening all interior and exterior lines. Fill in any rough edges on the house with a no. 4 flat sable brush. Darken the mixture and block in the doors and windows.

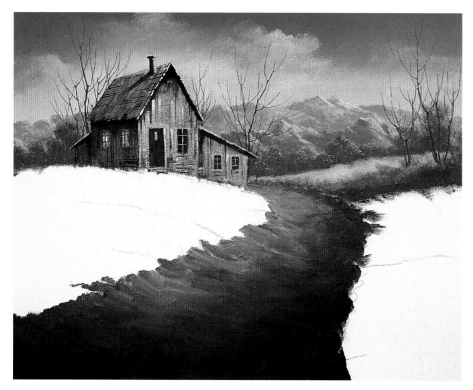

12 Detail House

Mix gesso with a very slight touch of Cadmium Orange. Drybrush vertical and horizontal strokes with this mixture to suggest old weathered boards. Use a no. 4 flat sable brush. Repeat for the roof to suggest shingles. Paint a few dark cracks with a mixture of Ultramarine Blue, Burnt Sienna and a touch of gesso. Add as many details as you want using a no. 4 script liner brush. Now add a touch of Dioxazine Purple to the dark mixture and paint the overhang shadows. If you want, light the windows using layers of Cadmium Orange and Cadmium Yellow Light. Determine how you want to finish the house. The sun is coming in from the right, so the right side of the house should be lighter. Don't paint too solidly when drybrushing lighter colors; let some of the background show through the brush strokes. Have fun, but don't over-detail.

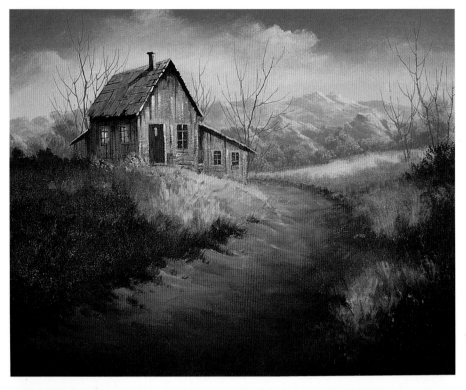

13 Underpaint Middle and Foreground Grass

Use lots of paint with this step. Beginning at the top of the foreground, brush in Thalo Yellow-Green and touches of Cadmium Yellow Light with a no. 10 bristle brush. As you come forward, add Hooker's Green Hue and touches of Burnt Sienna. Add Dioxazine Purple to the mixture when you arrive at the immediate foreground. Work quickly because the colors must stay wet. Remember, the paint mixture needs to be very thick. Now begin at the top layer and push the color up with a no. 10 bristle brush. Then work your way down, pushing each layer of color up against the previous color to create a variety of grass and bush-like formations.

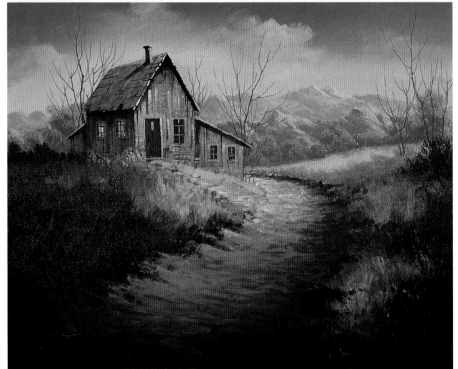

14 Highlight the Road

Detail the road with a no. 6 bristle brush. Mix Cadmium Orange and gesso to a creamy consistency. Highlight the road using short, choppy horizontal strokes beginning at the top. Use small amounts of the mixture. Don't blend too much because you want a rough texture. Let much of the background show through your strokes. Make a path up to the house by adding some fairly thick smudges of the Cadmium Orange and gesso mixture. Block in the ruts with a small amount of Burnt Sienna and Ultramarine Blue. Keep them smudgy.

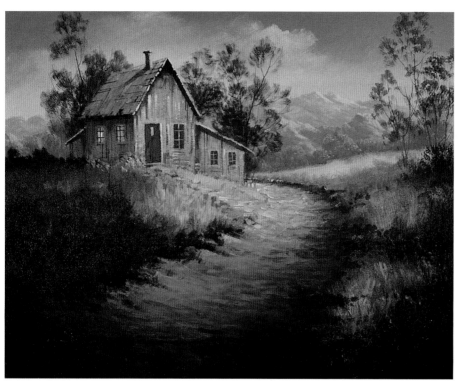

15 Add Leaves

Create a mixture of Hooker's Green Hue, a small amount of Burnt Sienna and enough gesso to lighten the value. Drybrush in leaves by barely skimming the surface of the canvas with a no. 6 bristle brush. Be sure these trees have good negative space around them and that they are fairly open so the viewer's eye can easily move around the leaf formations. Make sure some of the background shows through.

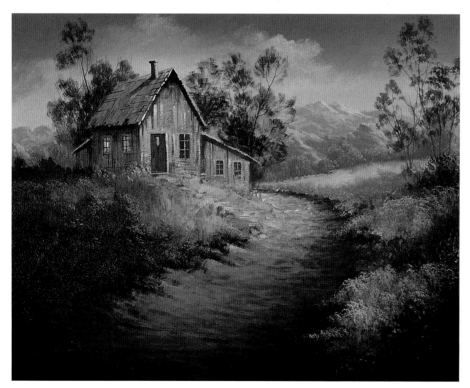

16 Highlight Middle and Foreground Grass

Pick any color or color combination as long as it complements the color scheme. Mix the colors to a slightly creamy consistency. Load a small amount of the mixture onto a no. 10 bristle brush. Paint the highlights with light, careful strokes. Carefully judge highlight placement. Negative space is your best friend, so keep most of the brighter highlights toward the middle of the foreground. Use your creativity with this step.

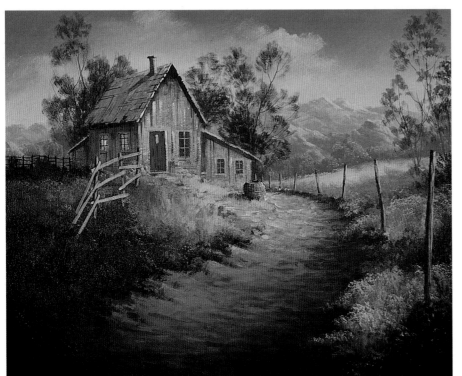

17 Add Miscellaneous Objects and Highlights

Create fairly dark-gray mixture of Burnt Sienna, Ultramarine Blue and a slight touch of gesso. Use any brush (I recommend the no. 4 round sable brush) in this step. Block in the fence posts, old rain barrel and any other objects you wish. Adjust the values of each object based on its location. Now add highlights to these objects with a sunshine mixture of gesso and slight touches of Cadmium Orange and Cadmium Yellow Light. Highlight each object again based on its location and the effect you want it to have on the painting.

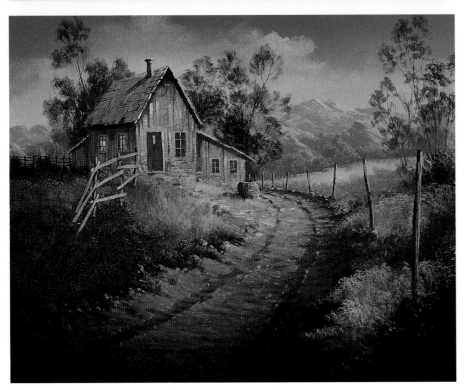

18 Detail Road With Rocks and Pebbles

Mix gesso with a touch of Cadmium Orange into a creamy consistency. Paint small smudges with a no. 4 round sable brush to suggest pebbles and small rocks along the edge of the road. Add many to make the road look fairly rocky. As you come forward into the dark part of the road, darken the mixture with a small amount of Burnt Sienna and Ultramarine Blue. This gives the details a soft grayish tone; they don't need to be as bright in the immediate foreground.

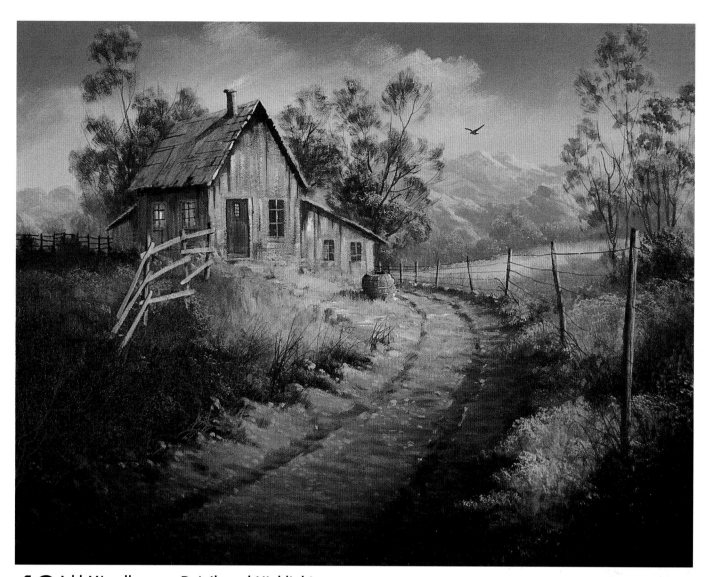

19 Add Miscellaneous Details and Highlights

You have many options here: You can paint flowers with pure color. Detail taller dark and light weeds with a no. 4 script liner brush. In the front corners, add some grayish dead bushes to act as eye-stoppers and to add contrast to the dark corners with a no. 4 bristle brush. Also add a bird or two flying in the distance, the wire on the fence and a few more details on the house with a script brush. These details finish this painting well.

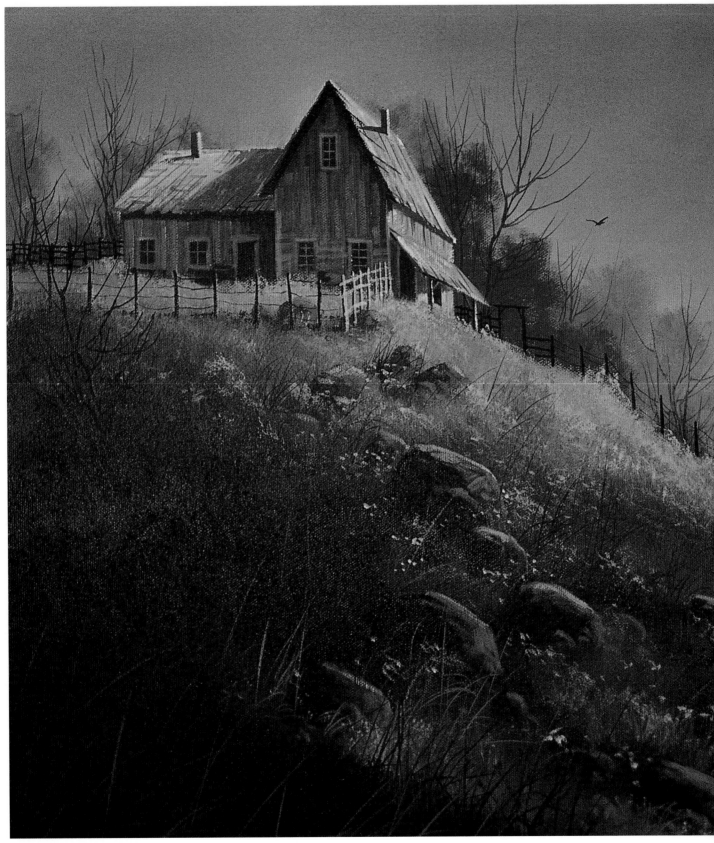

Hilltop Retreat
16" × 20" (41cm × 51cm)

Hilltop Retreat

Unlike the previous painting, in Hilltop Retreat, this house is sitting on top of a hill in the Osage hills where I live. The house's location adds a twist to the perspective. Sitting well above the horizon line, the house creates a common perspective problem. The vantage point is in a valley looking up at the house, which sits left of center. From this perspective, the angles of the rooflines are extreme, and more of the underside of the roof overhangs are visible. This is a one-point perspective problem because you can only see one side of the house. Another interesting aspect of this house is its irregularly shaped additions. Add as many lean-to sheds, extra doors, windows, chimneys and posts to the building as you wish. Have fun experimenting to create interesting perspective.

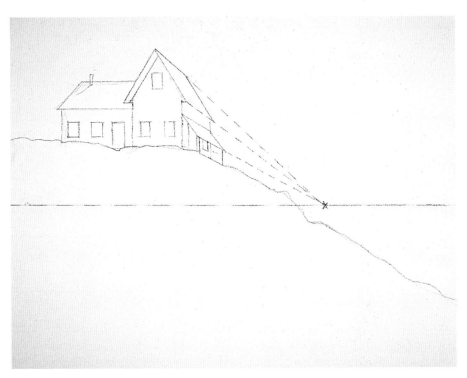

1 Sketch Basic Perspective

Make a rough sketch to determine the perspective on the right side of the house using no. 2 soft vine charcoal. Draw the roofline at an extreme angle. Place the horizon line below the bottom of the house's hilltop location. Place the vanishing point to the right, but still within the boundary of the canvas.

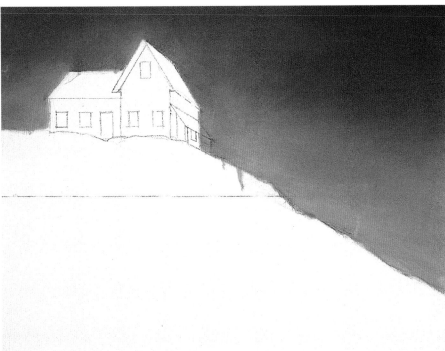

2 Paint Sky

Believe it or not, this entire piece is painted with Cadmium Yellow Light and Dioxazine Purple, with gesso to change the value. Apply a liberal coat of gesso to the canvas for the sky, using your hake brush. Then blend pure Cadmium Yellow Light all the way to the top. While the canvas is still wet, add Dioxazine Purple to the top of the sky. Use large crisscross strokes to blend the color downward until it fades into a soft color at the horizon.

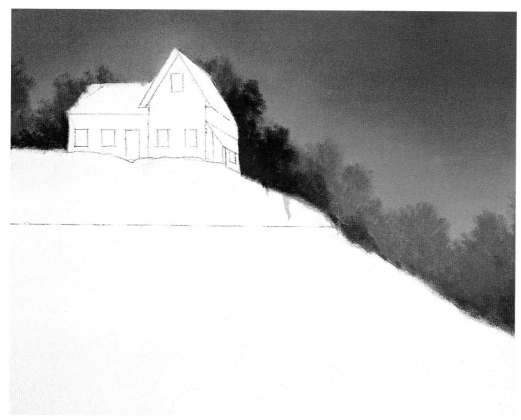

3 Paint Clouds and Background Trees

Notice these clouds are soft and feathery. You accomplish this by mixing gesso with Dioxazine Purple and Cadmium Yellow Light. Mix the value slightly darker than the sky. Scrub in these clouds using a no. 6 bristle brush. Now darken the color mixture used to make the clouds with a touch more Dioxazine Purple. Feather in distant trees so they have a soft edge using a no. 10 bristle brush. For the trees just behind the house, darken the mixture with a little more Dioxazine Purple and Cadmium Yellow Light, and scrub in a broad group of trees using a no. 10 bristle brush.

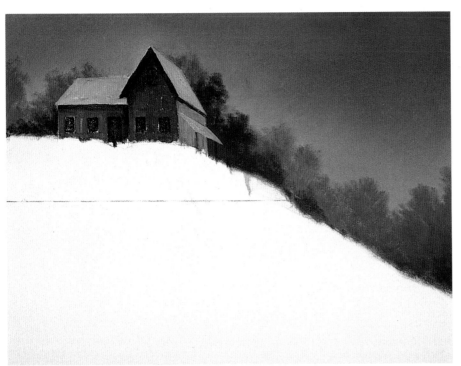

4 Underpaint House

Mix a base color of Cadmium Yellow Light, Dioxazine Purple and a little gesso to create a midtone. Underpaint the left side of the house with your no. 4 flat bristle brush. Use long vertical strokes. Add a little more gesso to the mixture and block in the roof. Add more gesso to the front of the house. Next mix Dioxazine Purple and Cadmium Yellow Light to create a dark value. Don't add any gesso. Block in the doors and windows with your no. 4 flat sable brush.

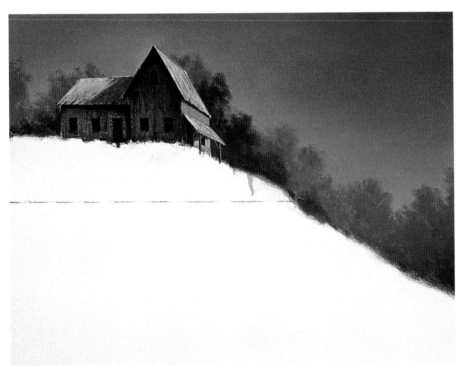

5 Detail House

Add more gesso to the underpainting mixture you used in step 4. Load a small amount of the mixture on the tip of a no. 4 flat sable brush. Now, drybrush long vertical strokes on the side of the house to suggest weathered wood. Use light pressure so some of the background shows through. Mix gesso with a touch of Cadmium Yellow Light and drybrush this on the front of the house and roof to suggest sunlight hitting the side. Use your creativity to paint different effects. Drybrush a darker value to the shadows that overhang.

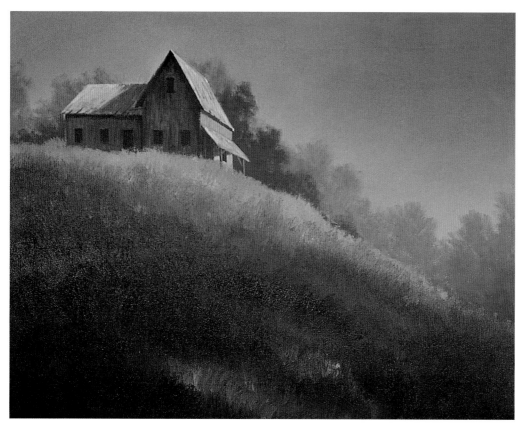

6 Underpaint Hillside

For success in this step, work quickly and use thick paint. Apply a thick layer of Pure Yellow along the top of the hillside with a no. 10 bristle brush. Add more thick paint as you move into the middle ground. Add Dioxazine Purple to create a midtone. Then add more Dioxazine Purple as you come forward to create a dark value. The canvas is still wet, so work quickly. Wipe the excess paint from your brush and begin at the very top of the hillside, moving across the hill and then down until you have a textured hillside that has light, medium and dark values.

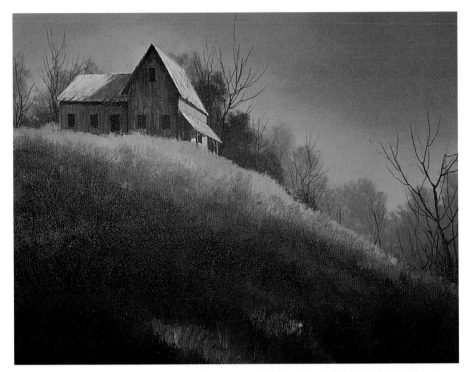

7 Paint Background Tree Limbs

This should be a fairly familiar step by now. Create a slightly darker value than the second layer of background trees. Add plenty of water to make the paint ink-like. Paint in tree limbs along the top of the hill with a no. 4 script liner brush. Create depth by changing the value of some of these trees. Avoid making the area too busy.

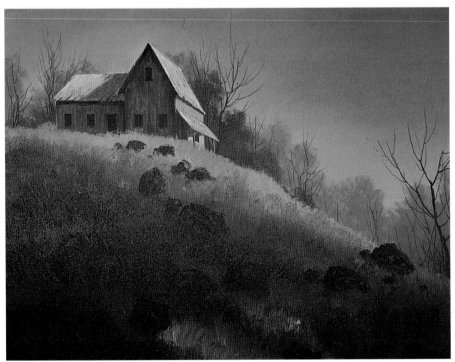

8 Underpaint Rocks

Create a dark mixture of Dioxazine Purple and Cadmium Yellow Light; Dioxazine Purple is the dominant color. Block in a collection of rocks scattered throughout the hillside using a no. 6 bristle brush. Vary the sizes and shapes. Overlap the rocks so the negative space creates good eye flow. Paint the larger rocks toward the center of the hillside and the smaller rocks closer to the house and in the foreground.

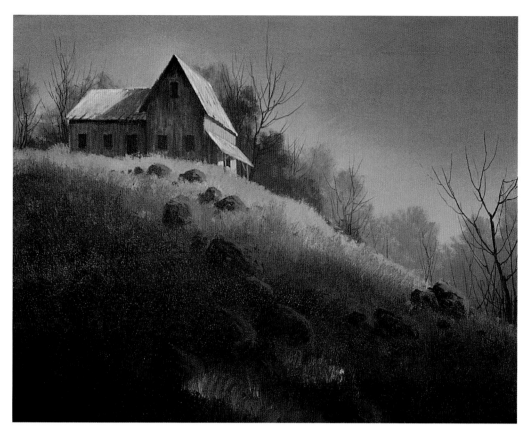

9 Highlight Rocks

Mix gesso with a little bit of Cadmium Yellow Light and Dioxazine Purple. Don't mix a bright highlight yet—this should be a midtone. Highlight the side of each rock with your no. 6 or no. 4 bristle brush. Make sure to drybrush the highlight. Don't leave a hard line where the dark and light sides meet each other. Try short, choppy strokes.

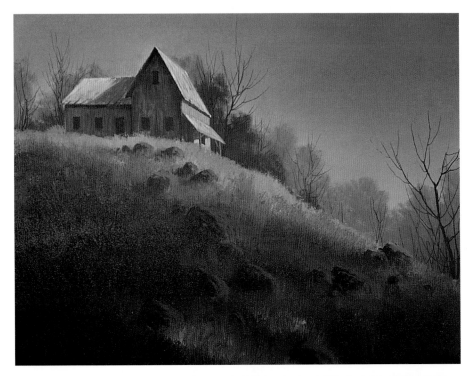

10 Paint Grass Around Rocks
If your rocks appear to be floating, pull up the grasses tall enough to hide the bottom of each rock. Use a no. 10 bristle brush and the same colors you used for the underpainting of the hillside. Mix the colors accordingly, to match their location on the painting. Make the mixture a little creamy.

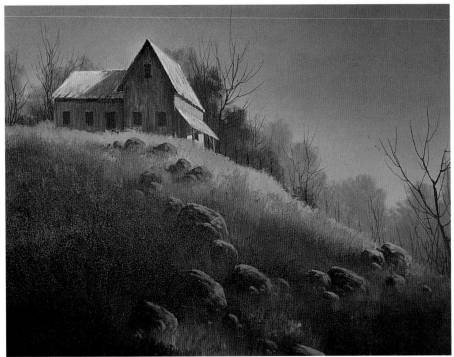

11 Enhance Rock Highlights
Now you are ready to add sunlight. Mix gesso with a touch of Cadmium Yellow Light. Make the mixture fairly creamy. Drybrush on a thin layer of paint with your no. 4 or no. 6 bristle brush. Let dry. Repeat this step one or two more times until you are satisfied with the intensity of the highlight. It won't be necessary to enhance the entire highlight, just add spot highlights to accent the rocks.

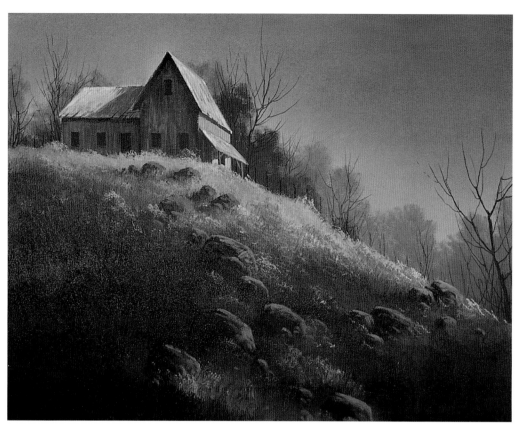

12 Highlight Hillside

Have fun with this step. Make two light highlight mixtures. First mix Pure Yellow with a little water to make it creamy. Then mix Cadmium Yellow Light with a little gesso and water to make it creamy. Now, begin painting in highlights with your no. 10 bristle brush. Scatter them throughout the light areas of the hillside and use them to suggest bushes and brush in the surroundings.

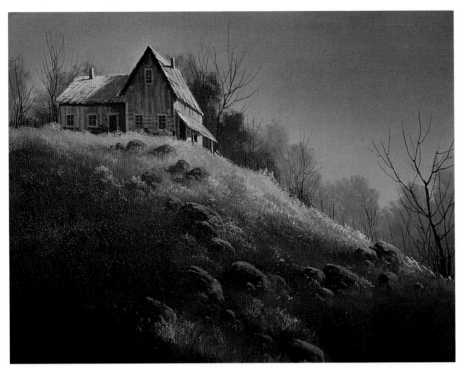

13 Accenting House Details

Add all of the miscellaneous details. Paint the cracks and miscellaneous dark areas using the no. 4 flat, no. 4 round and no. 4 script liner sable brushes. Experiment to see which brush works best for you. Use a dark mixture of Dioxazine Purple with a touch of Cadmium Yellow Light. Accent the lighter areas with a mixture of gesso and a touch of Cadmium Yellow Light. These old houses are great fun to play with, so enjoy yourself.

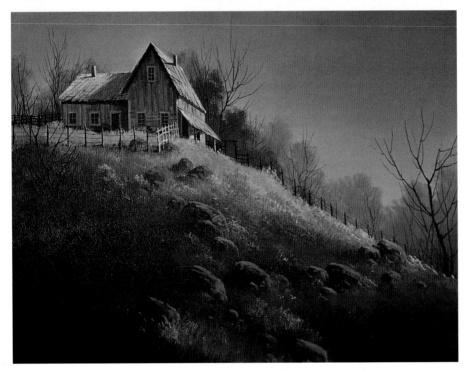

14 Add Fence Posts and Landscape Details

Add water to the same mixtures you used in step 13 to make an ink-like consistency. Add the taller dark and light weeds with your no. 4 script liner brush. Then add the dead bush on the left side as an eye-stopper. Paint in the fence posts, wire and bird with the no. 4 round sable brush. Use the lighter highlight for the fence close to the house. Paint in the suggestion of wildflowers throughout the hillside with Pure White.

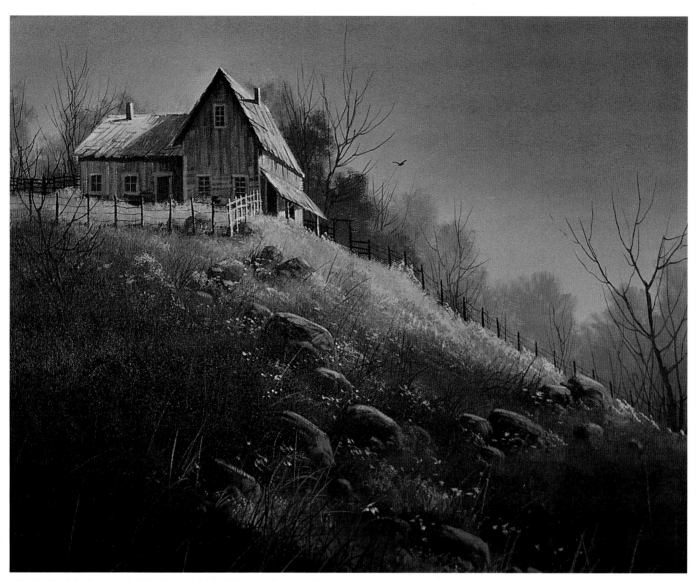

15 Add Final Highlights and Additional Weeds

Create ink-like mixture of a dark value such as Hooker's Green Hue and Dioxazine Purple and paint in some tall weeds in the foreground and around the fence posts and the edge of the road using a no. 4 script liner brush. Lighten the same mixture with a touch of Thalo Yellow-Green and gesso. Paint in some lighter tall weeds in the immediate foreground. Brighten dull areas by dragging in some pure colors with a no. 4 round sable brush.

Evening Shadows
16" × 20" (41cm × 51cm)

Evening Shadows

This painting is fun to complete with its beautiful fall colors, late evening sunset and strong cast shadows. There also is a perspective problem to solve. In this painting, there are two buildings sitting on top of a slight hill, one on each side of the road. This is a one-point perspective problem because you are finding the perspective on only one side of each building. Remember, you can have several vanishing points in one-point perspective, if you have several buildings that are not in line with one another. So sharpen your pencil and have fun with this perspective problem. Don't be afraid to move the buildings around slightly to exercise your artistic license.

1 Paint Sky

Paint the sky with a liberal coat of gesso using a hake brush, adding a small amount of water to make a creamy mixture. Add a small amount of Cadmium Yellow Light and Cadmium Orange at the horizon. Blend up to the top of the sky. While the paint is still wet, blend across the top of the sky a mixture of Ultramarine Blue with touches of Dioxazine Purple and Burnt Sienna. Use choppy, slightly angled vertical strokes to work your way across the canvas from left to right, suggesting a semi-cloudy or stormy sky.

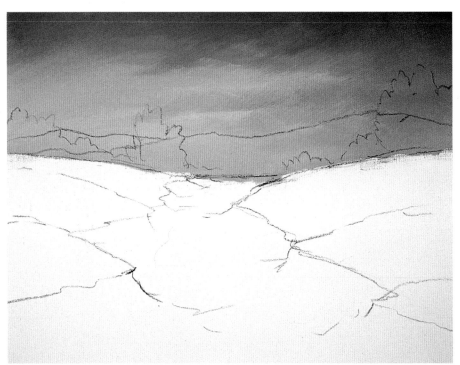

2 Make Rough Sketch of Landscape

This is a very simple step. Make a very rough and loose sketch of the landscape's basic components using no. 2 soft vine charcoal. Don't find the perspective of the houses yet—you will do that in step 7.

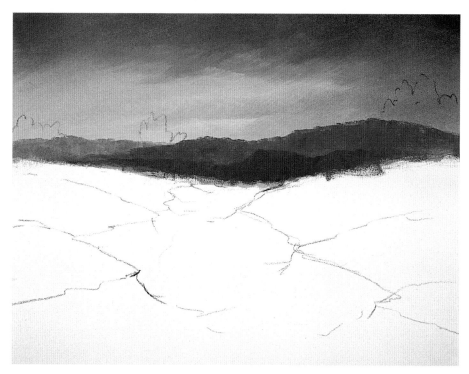

3 Underpaint Background Hills

There are two layers of hills here. Paint the background layer with a mixture of gesso and touches of Dioxazine Purple and Burnt Sienna. This layer is slightly darker than normal because it is late in the evening. Block in the trees with a no. 6 bristle brush. Give it a fairly rugged shape. Take this mixture and darken it slightly with a little more Dioxazine Purple and Burnt Sienna. Block in the next layer with the same brush. Make it fairly rugged.

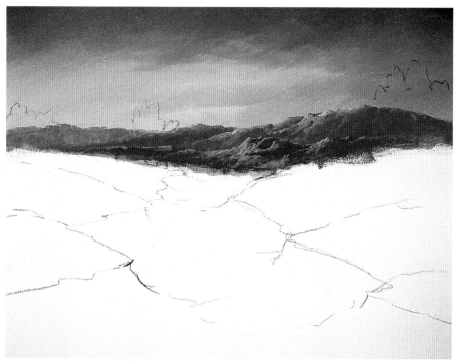

4 Highlight Background Hills

Create a mixture of gesso with a touch of Cadmium Orange. Drybrush some simple, soft highlights to the most distant layer of hills with a no. 4 flat sable brush. Add a bit more Cadmium Orange to the mixture and highlight the closer layer of hills. There is not much highlighting you need to do here. The main front peak is significantly brighter because the sun is coming from the left side. Notice the larger dark pockets of negative space on the right side of each highlight.

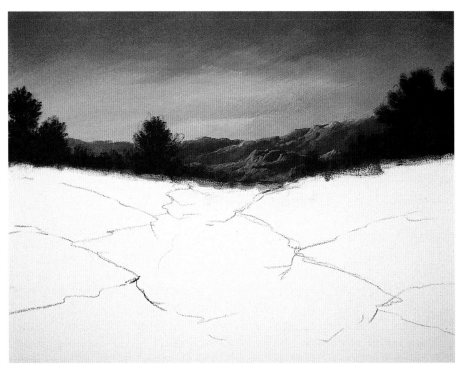

5 Block In Background Trees

Give the trees a rich brownish tone with a mixture of Burnt Sienna and a small amount of Dioxazine Purple. Add the amount of gesso you need to achieve a value that is darker than the background hills. Scrub in a collection of trees with a no. 6 or no. 10 bristle brush. Be sure each tree has good negative space. Notice the larger trees are located closer to the outer edges of the painting, creating an area of transition between the background and foreground.

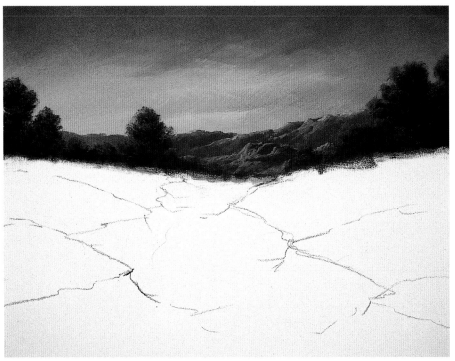

6 Highlight Background Trees

Highlight the background trees with a mixture of Cadmium Yellow Light mixed with a touch of Cadmium Orange and gesso. Adjust the color to fit your taste without making it too bright. Carefully paint on the highlights with a no. 6 bristle brush. Don't make the highlights too solid. Keep a small amount of the background showing. This gives the trees a three-dimensional effect.

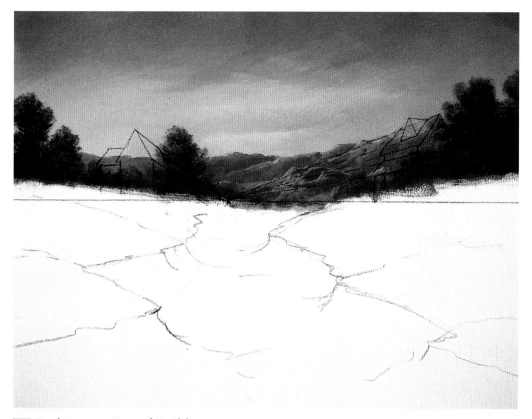

7 Find Perspective of Buildings

Place the vanishing point on the midground between the two houses. Both houses use the same vanishing point. Find the perspective of the left side for the house on the right, and the right side for the house on the left. Reference this procedure on page 27.

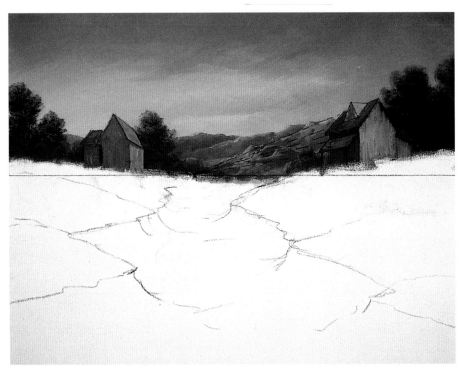

8 Underpaint Buildings

Create a mixture of Ultramarine Blue, Burnt Sienna, a touch of Dioxazine Purple and enough gesso to create a soft, rich gray tone. Block in the buildings to establish their shape. Give them a good base for you to highlight and detail later. Don't worry about the direction of the sun yet. Use a no. 4 flat sable brush, no. 4 round sable brush and possibly a no. 4 bristle brush. Mix together Burnt Sienna, Ultramarine Blue and a touch of Dioxazine Purple for the dark areas of the doors and windows.

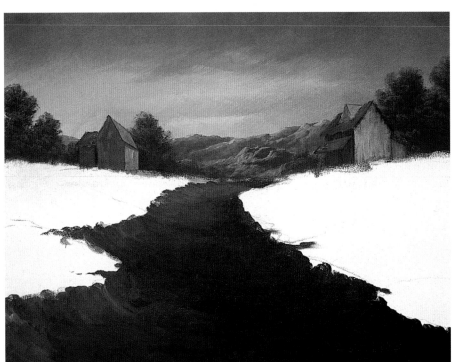

9 Underpaint Road

Mix Burnt Sienna, gesso and a touch of Dioxazine Purple on your canvas. Add a touch of Cadmium Orange at the back of the road. Block in the road using short, choppy, overlapping horizontal strokes with a no. 10 bristle brush. Don't worry about the direction of the sun. Just underpaint and create some texture to suggest dirt.

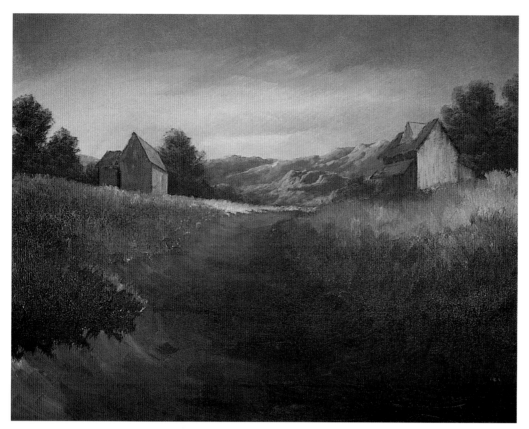

10 Underpaint Grass

Use very thick layers of paint in this step, and work quickly while the paint is still wet. Use a no. 10 bristle brush. Paint the grass on only one side of the road at a time; this will give you blending time. Beginning at the top of the hillside, lay on Cadmium Yellow Light with touches of Burnt Sienna and Cadmium Orange. As you come forward, add more Burnt Sienna and touches of Dioxazine Purple to darken the corners. Beginning at the top of the hill and working your way down, push each color up over the previous layer with a no. 10 bristle brush. Repeat until you have a light, middle and dark value, creating a three-dimensional hillside.

11 Highlight and Shadow the Road

In this step, the highlights and shadows of the road fall in line with the direction of the light source. To shadow the road, mix Burnt Sienna with a touch of Dioxazine Purple to a creamy consistency. Begin adding the shadows on the left side of the road with a no. 6 bristle brush. Work them out to the middle of the road. On the right side of the road, mix gesso with a touch of Cadmium Orange. Paint short, comma strokes along the edge with the same no. 6 bristle brush. Then flatten the stroke out to a short choppy horizontal stroke, gradually working your way out toward the center of the road to the shadow. Blend the two values together with short, choppy horizontal strokes where they meet in the center of the road.

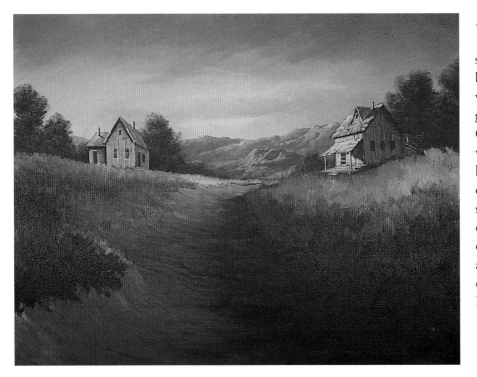

12 Highlight Houses

Highlight both houses the same way. Use your creativity to drybrush strokes suggesting weathered wood. Mix a base sunshine color of gesso with a touch of Cadmium Orange. Don't hesitate to change the value and color for each side of the house. Simply drybrush on a facade of old boards and shingles on the left side. Then darken the mixture and drybrush the suggestion of boards on the shadowed side. Detail cracks and other dark areas with a mixture of Burnt Sienna and Ultramarine Blue using a no. 4 script liner brush.

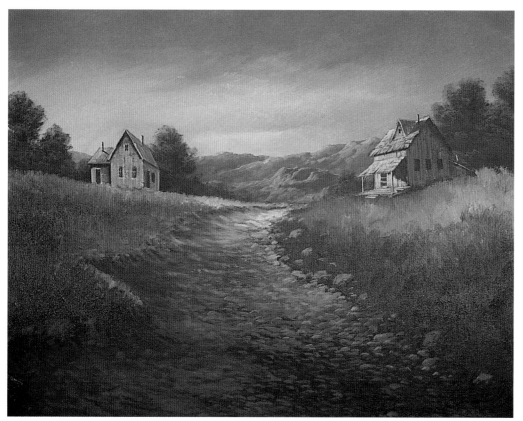

13 Highlight Rocks and Pebbles

Mix a base of gesso with a touch of Cadmium Orange and Cadmium Yellow Light. Paint in the small rocks and pebbles with a no. 4 flat sable brush. The secret is to use a very small amount of paint on your brush. Keep the paint's consistency thin and glaze-like. As you come forward into the front of the road, darken the mixture slightly by adding a small amount of Burnt Sienna and Dioxazine Purple. The rocks in the foreground are more shadowed. Try switching to a no. 4 round sable brush for the smaller pebbles. Remember to overlap the rocks and pebbles to create continuity and good composition.

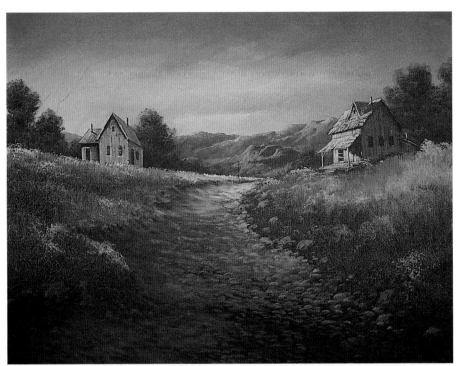

14 Highlight Grasses

This technique works well to brighten the grass by adding highlights, flowers or accents. Load on a no. 10 bristle brush a mixture of Cadmium Yellow Light and Cadmium Orange, or Cadmium Yellow Light and Pure Orange. You can also use just the pure colors for the various accents. Also add a small amount of gesso to these mixtures if you want to make them appear brighter. Paint the highlights on various locations throughout the sunlit areas. Use a light touch to ensure the highlights are not too solid.

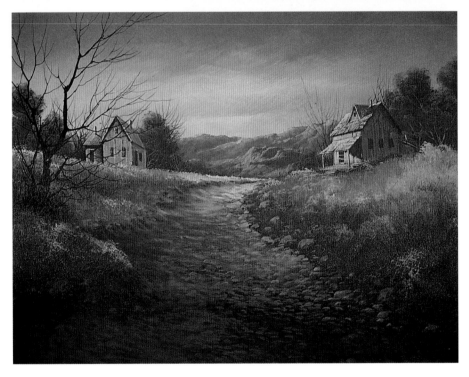

15 Paint Large Tree

Use pure Burnt Umber in this step. We don't use Burnt Umber much, but it works well for this tree. Mix Burnt Umber and water to an ink-like consistency. Paint in a well-shaped tree with a no. 4 script liner brush. Make it fill the left side. Notice that the tree actually goes off the canvas at the top and side. Be sure you overlap the tree limbs.

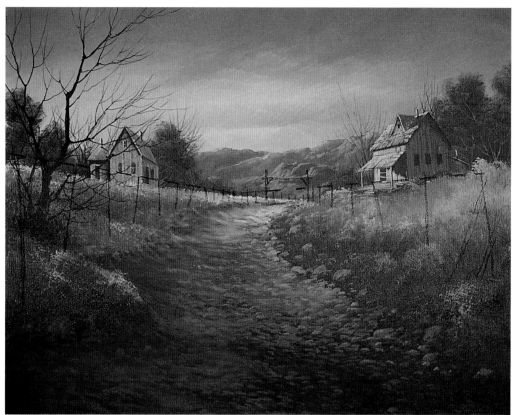

16 Find Perspective of Fence Posts

Since the fence posts are aligned with the sides of the houses that have perspective, they use the same vanishing point. Locate the first post in the foreground. Sketch it in proportion with the foreground. Now, draw a vanishing line from the top of the post back to the vanishing point. Simply sketch in each post between the vanishing line and the ground. Because these posts are hidden in the grass, there is no need to find their perspective at the bottom. As the posts recede into the distance, they get closer together.

17 Paint Fence Posts

Load a creamy mixture of Burnt Umber and water onto a no. 4 round sable brush. Paint in each post, making each one a little different from the others. These are old posts, so make them a little crooked and rough. As the posts recede into the distance, their value becomes slightly lighter.

18 Add Shadows

Carefully drybrush the cast shadows on the road with a mixture of Burnt Sienna and Dioxazine Purple. Add enough water to make it creamy. Load a small amount onto a no. 4 flat sable, or try any other brush you like and add the shadows. Cast shadows always follow the contour of the land. Be sure the shadows have very soft edges.

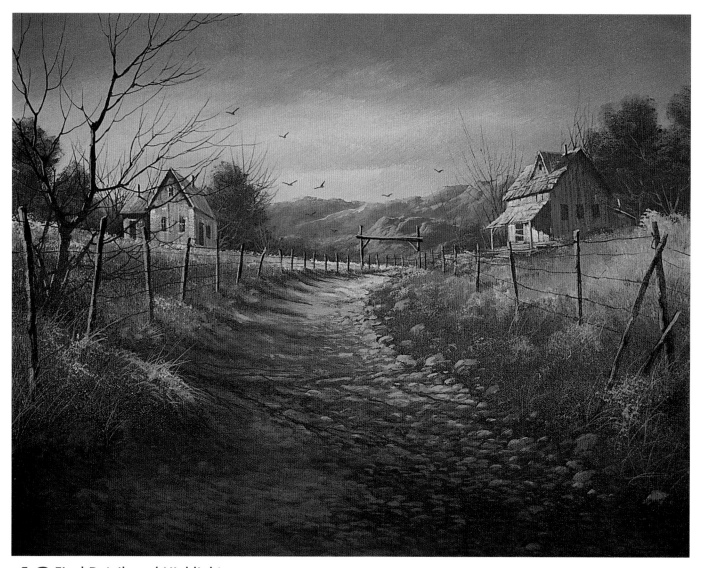

19 Final Details and Highlights

Add a few tree limbs behind the houses and a few brighter highlights on the grass. Some light-colored weeds that contrast against the darker background are a great accent. Highlight the fence posts and add the wire. The highlight is a mixture of gesso, Cadmium Orange and Cadmium Yellow Light. The wire is Burnt Umber thinned with water. A few birds and flowers are nice. It's possible that some brighter highlights will be needed on the sunlit side of the houses.

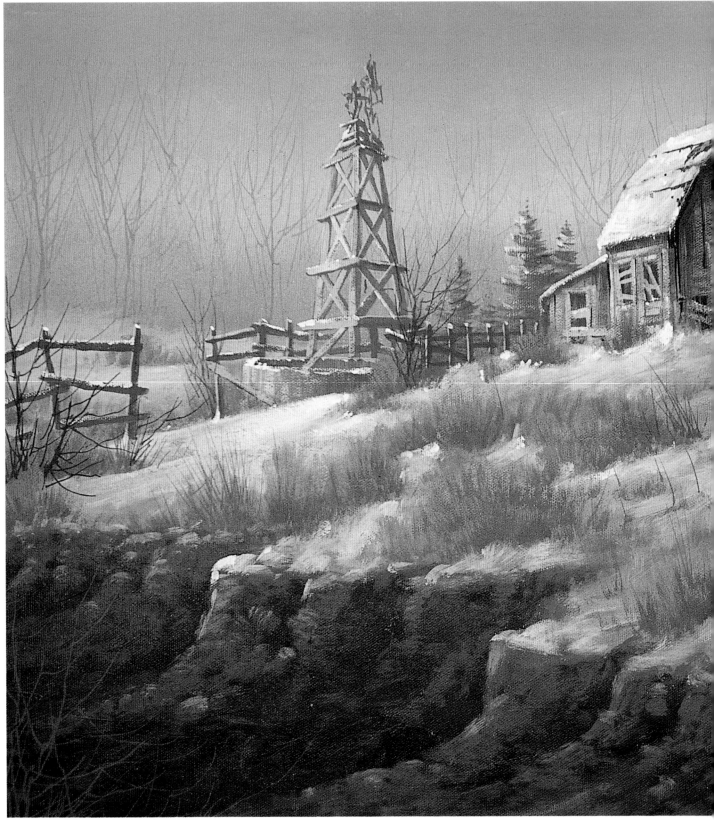

In Need of Repair
16" × 20" (41cm × 51cm)

In Need of Repair

Now that you have worked on a few one-point perspective problems, let's look at a scene with two-point perspective. This windmill requires two-point perspective because you are finding the perspective of both of its sides. However, the barn in the background only requires one-point perspective on its left side. Notice how the barn and windmill sit below the horizon.

Here, we have a late fall with a light snow. This makes a great combination of contrast, texture, light and shadows. The value changes in the painting are important because they create the contour of the snow and atmosphere.

Painting snow is one of the challenges of landscape painting. This painting will challenge you in several other ways as well.

1 Paint Sky

Draw an uneven line separating the sky from the ground using no. 2 soft vine charcoal. Apply a liberal coat of gesso across the entire sky with a hake brush. While the gesso is still wet, paint Cadmium Red Light across the horizon. Blend all the way up until the sky is a soft pink. While the sky is still wet, paint Ultramarine Blue across the top of the sky and blend down until the sky is fairly well blended.

2 Underpaint Background and Sketch Landscape

Mix gesso with a hint of Ultramarine Blue, a touch of Burnt Sienna and Dioxazine Purple. Adjust the value slightly darker than the sky. Feather this color into the background with a no. 10 bristle brush, so you have soft edges. Instead of detailing trees, create a soft background for depth and a snowy atmosphere effect. Scrub fairly hard to soften the edges. Sketch the landscape under the sky.

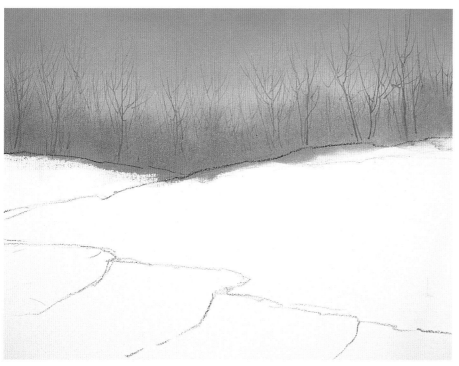

3 Paint Background Trees

Slightly darken the mixture you used in step 2, and thin it to an ink-like consistency. Paint a collection of tree limbs with a no. 4 script liner brush. These are small, distant trees, so don't make them too big, dark or busy. They shouldn't compete with anything in the painting.

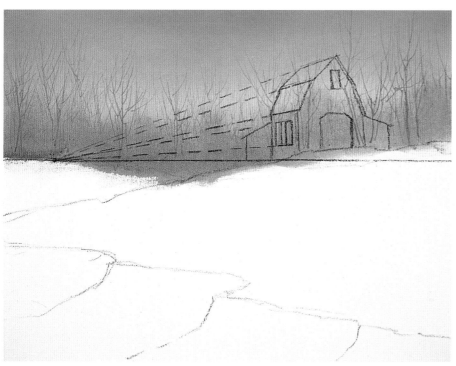

4 Find Barn Perspective

The horizon line is below the base of the barn. The vanishing point is located far to the left and is dictated by the angle or pitch of the roofline. Here the roof angle allows the vanishing point to stay within the boundary of the canvas. If your roof angle is less steep, your vanishing point may be off the canvas. You then add an extension to draw the perspective. Complete the perspective after locating the vanishing point and horizon line.

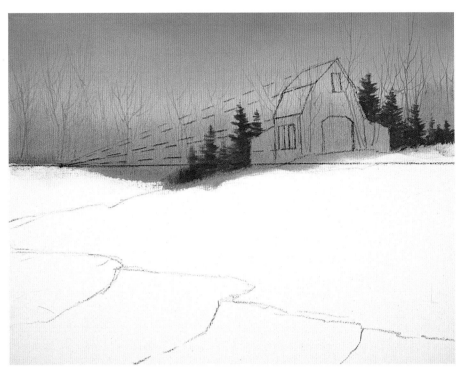

5 Paint Cedar Trees

Mix Hooker's Green Hue with a touch of Dioxazine Purple, Burnt Sienna and enough gesso to change the value to fit your painting. Paint a collection of cedar trees just behind and slightly to the sides of the barn with either a no. 4 or no. 6 flat bristle brush. All the trees overlap each other, but they have their own shape with interesting pockets of negative space around them.

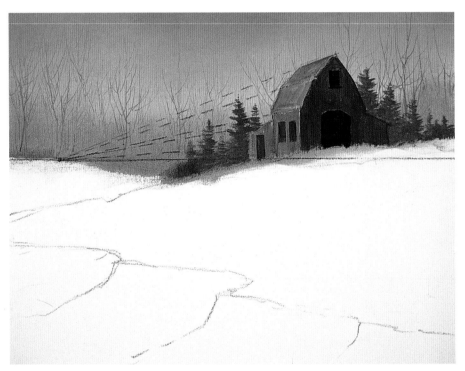

6 Underpaint Barn

Mix Cadmium Red Light with a touch of Burnt Sienna, Ultramarine Blue and gesso. This is an old weathered red barn, so the undertone must be fairly warm hue. First paint the dark side of the barn, using a no. 4 or no. 6 flat bristle brush. Block in the lighter side of the barn, adding even more gesso to the mixture. Block in the roof adding more Ultramarine Blue and gesso to the mixture. The underpainting for the roof needs to be more gray since it is going to be covered with snow. Paint the doors and windows with a mixture of Ultramarine Blue, Burnt Sienna and Dioxazine Purple.

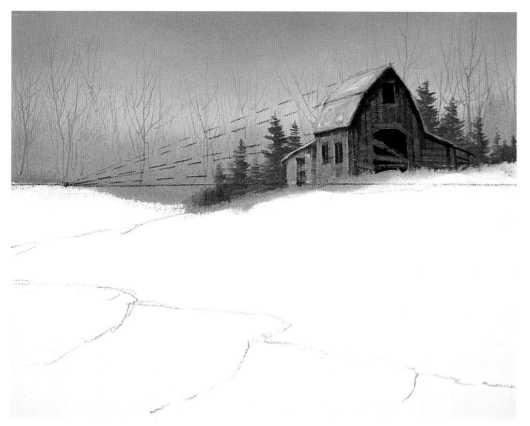

7 Detail Weathered Boards

Mix a base of Cadmium Red Light and gesso into a pinkish color. Drybrush a facade of weathered boards using a small amount of the mixture on a no. 4 flat sable brush. Paint the boards in any direction since this is an old patched barn. Allow some of the background to come through, so the boards look old and weathered.

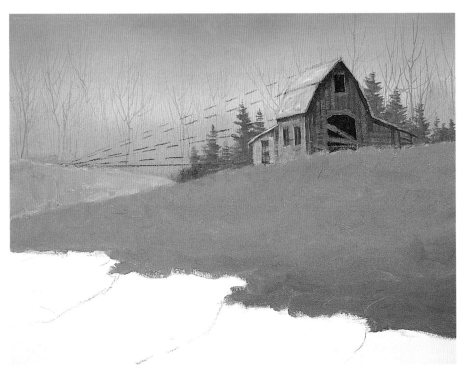

8 Underpaint Snow

Work out all your frustrations on this step. Begin applying gesso to the snow areas of the canvas with a no. 10 bristle brush. As you move across the painting with gesso, mix on the canvas Ultramarine Blue and touches of Dioxazine Purple and Burnt Sienna with very loose, unorganized strokes. The overall color is a soft, grayish-purple. Show lots of brushstrokes.

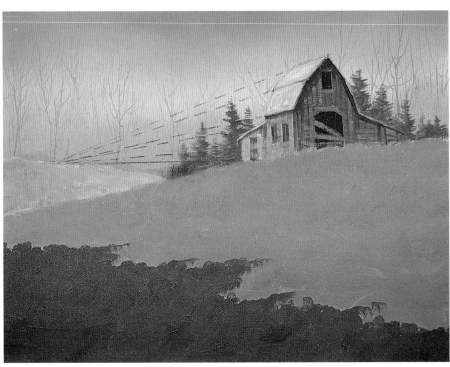

9 Underpaint Foreground Banks

The banks are a rich, warm brown. Mix this color out of Burnt Sienna, Dioxazine Purple and a small amount of Ultramarine Blue. Make large comma strokes with a no. 10 bristle brush. Paint thick enough to cover the canvas. Texture the top edge of the banks fairly roughly.

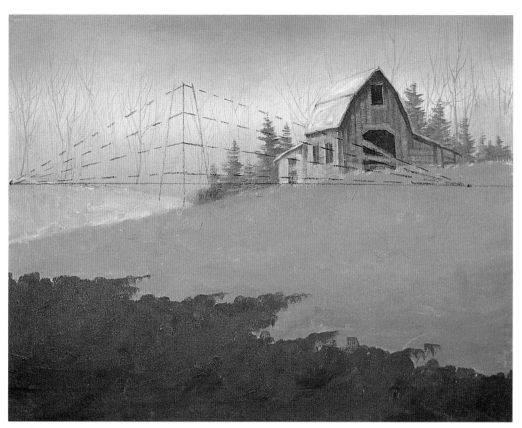

10 Find Perspective of Windmill Base

This requires two-point perspective. Refer back to the front of the book to reference this technique. Use the same horizon line from page 35. Locate the center leg of the windmill and draw a vertical line. Put four or five dots on the front leg, spaced as far apart as you want the braces to be. Locate the vanishing points, one far to the left and one far to the right. Find the perspective of the braces by drawing a vanishing line from each dot back to the vanishing point. Draw in the other two legs. Place them to your preference.

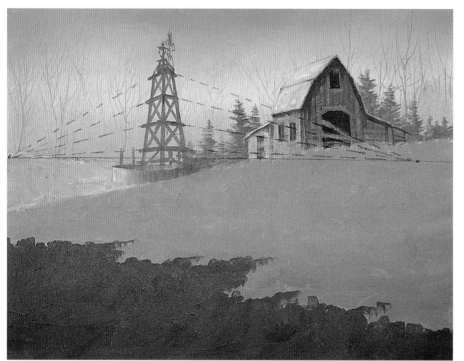

11 Underpaint Windmill and Tank

Mix Burnt Sienna, Ultramarine Blue and a touch of Dioxazine Purple to a creamy consistency. Add some gesso to change the value and water to lighten the texture. Block in the windmill with a no. 4 flat sable brush. Don't hesitate to switch to a no. 4 round sable brush for some of the smaller areas. Block in the tank. The left side of it is a little lighter than the right side. The inside of the tank is the dark value.

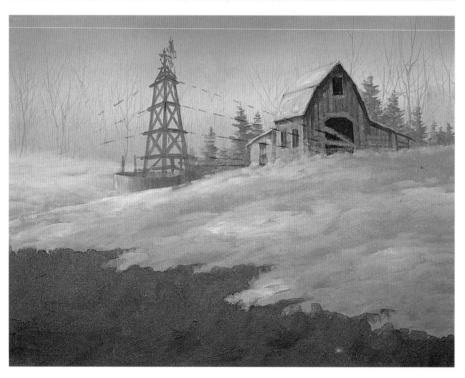

12 Highlight Snow

Mix a creamy combination of gesso with a hint of Cadmium Orange. Scrub on this first layer of highlights with a small amount of the mixture using a no. 10 bristle brush. Allow some of the underpainting to show through, leaving various pockets of negative space to give the snow contour and the suggestion of drifts. These pockets are also a great place to put the clumps of grass, which you will paint in the next step.

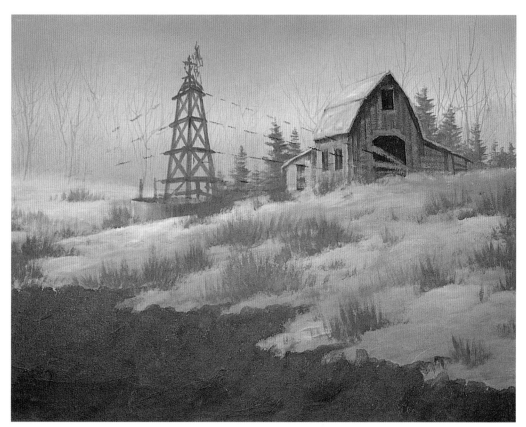

13 Add Clumps of Grass

Create a creamy midtone out of Cadmium Red Light, Ultramarine Blue and gesso. Pull up clumps of grass scattered throughout the middle ground, using an upward dry-brush stroke with a no. 6 bristle brush. Make the clumps different shapes and sizes, and overlap them.

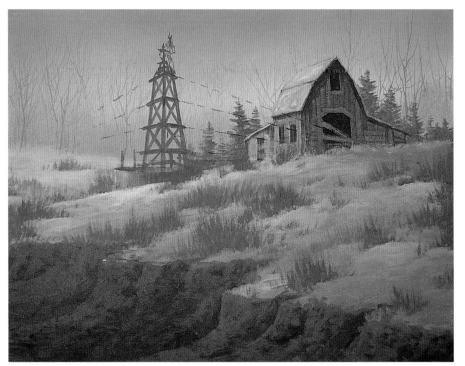

14 **Shape Snow Banks**
These banks remain more in the shadows, so use a cool color to suggest their form. Mix Ultramarine Blue, some Burnt Sienna and a gesso into a soft, cool gray. Drybrush these highlights with a no. 4 flat bristle brush. Use a combination of short, choppy, vertical and horizontal strokes. Leave plenty of the darker underpainting showing through, so the banks appear three-dimensional. You will add final highlights later.

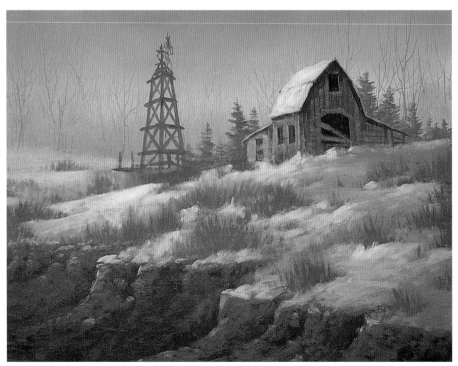

15 **Accent Snow**
Mix gesso with a hint of Cadmium Orange to create brighter accent highlights. Drybrush the effect of show drifts using the highlight mixture with a no. 4 flat bristle brush, against the grass base, along the edge of the snow banks and against the barn base. Scatter these highlights in other areas throughout the middle ground. Don't completely cover up the underpainting.

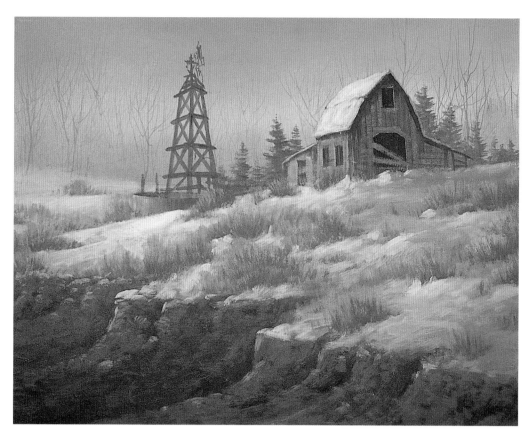

16 Highlight Clumps of Grass

This step adds a warm feeling to this painting. Mix Cadmium Orange, Cadmium Red Light and gesso. Starting at the top of each clump of grass, drybrush downward, creating a soft, feathery highlight with a no. 6 bristle brush. Repeat this step once or twice until you achieve the brightness you want.

17 Paint Fence Posts

Mix Burnt Sienna, Ultramarine Blue, a touch of Dioxazine Purple and gesso, to lighten the value. Sketch in the location of each post with no. 2 soft vine charcoal. Paint in all the posts and crossbraces with a no. 4 flat sable brush or a no. 4 round sable brush. Give this old, broken-down fence lots of character.

18 Detail Windmill and Barn

Use your artistic license to detail these objects to your own taste. Remember, these are old weathered objects, so be as creative as you can. The best highlight color to use is gesso with a touch of Cadmium Orange. The best brushes to use are the no. 4 flat and round sable brushes for the larger details, and a no. 4 script liner brush for the fine-line details. Have fun with this step, but don't make the details too busy.

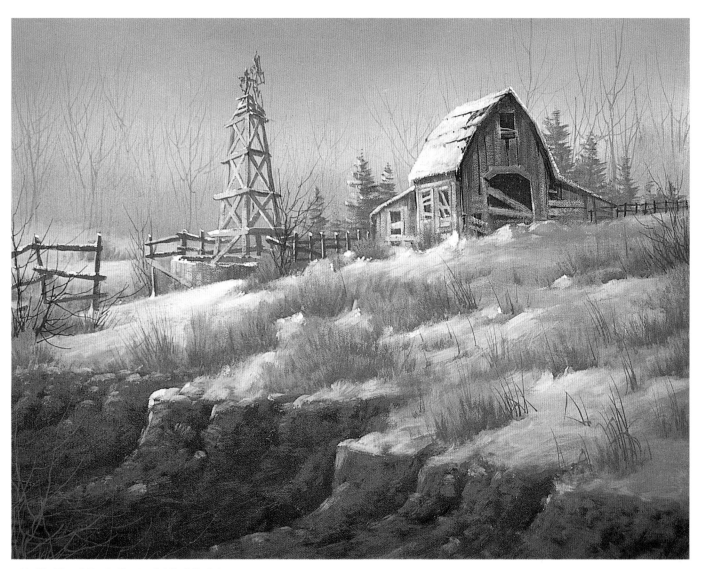

19 Final Details and Highlights

It's hard to know when to stop sometimes. This painting doesn't require much additional detail. Here are some enhancements you could make: Add a few bright white accent highlights on the fence, windmill and a few areas scattered throughout the clumps of grass using gesso. A few dark-colored weeds and dead bushes always add a nice touch. Be careful not to make these final details too busy, or they might compete with the main focal point.

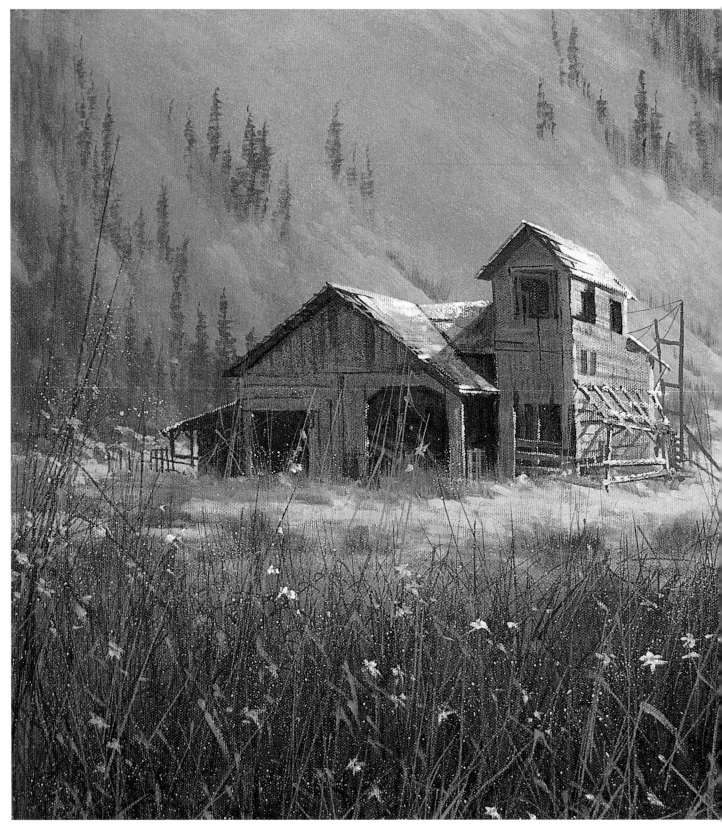

Lost in Time
16" × 20" (41cm × 51cm)

Lost in Time

I found this old building on a research trip near Silverton, Colorado. It is a remnant of an old mining operation. This building's different angles, shapes, sizes and attached structures give you many opportunities to practice one- and two-point perspective techniques. This building is located at the base of a mountain. There is a wonderful collection of grasses, weeds, bushes and dead limbs making up the entire foreground. Creating these close-up foreground details gives your script brush a good workout. This painting is really exciting, so let's get started.

1 Underpaint Background

A mountain base takes the place of a sky in this painting, so you want a multicolored grayish background. Slightly wet the canvas with gesso using a hake brush. While the canvas is still wet, use angled strokes to blend together Hooker's Green Hue, Burnt Sienna, Dioxazine Purple and touches of Ultramarine Blue with a hake brush. Blend in any other colors as long as no color stands out over the others.

2 Create Pine Trees

Many pine trees grow on the sides of these mountains. Mix Hooker's Green Hue, Burnt Sienna, a touch of Dioxazine Purple and just enough gesso to lighten the value—you don't want the trees to stand out too much. Paint in the pine trees using a no. 4 flat bristle brush. These pines are not detailed; they are only suggestions of trees. They are also scattered throughout the background, creating good eye flow with interesting pockets of negative space. You don't want repetitive clumps of trees. Add more details to this background later if necessary.

3 Highlight Hillside

This is a fairly simple and quick step. Mix gesso with Cadmium Yellow Light and Cadmium Orange. As you begin highlighting, try adding more Cadmium Yellow Light, Cadmium Orange or even touches of Thalo Yellow-Green. You only want to create subtle form highlights. Drybrush a few soft highlights around and through the collection of pine trees with a no. 4 or no. 6 bristle brush. Follow the contour of the hillside with your strokes.

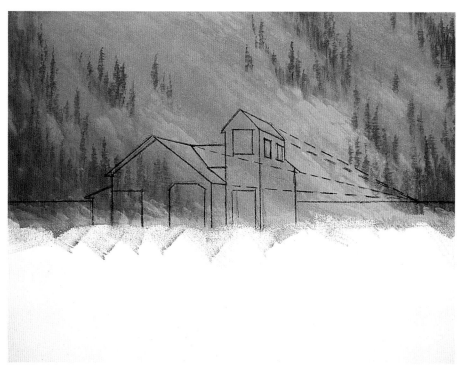

4 Find Building Perspective

It isn't difficult to find one-point perspective here. Locate the horizon line. Sketch in the fronts of the buildings, the way they appear in the photo. Set them slightly below the horizon line. Place the vanishing point near the edge of the canvas. Draw a vanishing line back to the vanishing point from the top of each roof peak. Draw roof lines, doors, windows and the end of the building. If you have any problems, refer back to the one-point perspective lesson on page 20.

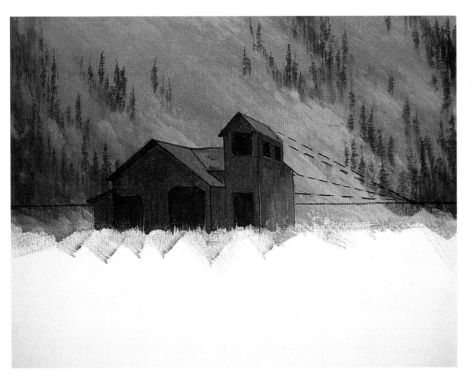

5 Underpaint Building

To achieve this building's warm tone, mix Burnt Sienna with touches of Ultramarine Blue and Dioxazine Purple, creating a dark value. Block in the large openings with this value using a no. 4 flat sable brush. Add a hint of gesso to the mixture and paint the front, shadowed side of the building. Add more gesso and paint the sunlit side of the building. Add more gesso and paint the roof. You have just created four values, one for each building segment.

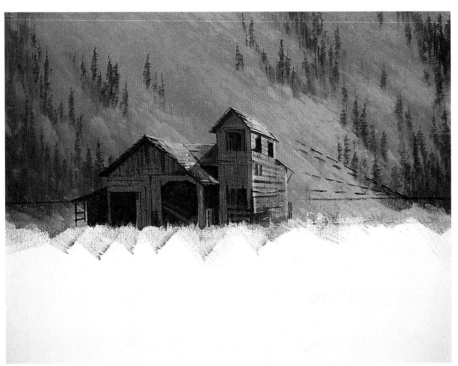

6 Detail Building

Mix gesso with Burnt Sienna to give the building a warm, reddish tone. The front should be a creamy midtone. Drybrush on the suggestion of weathered boards using a no. 4 flat sable brush. Lighten the mixture slightly and drybrush the boards on the lighter side. Add more gesso and drybrush the shadow on the roof. Have fun adding the facade of broken boards and other details.

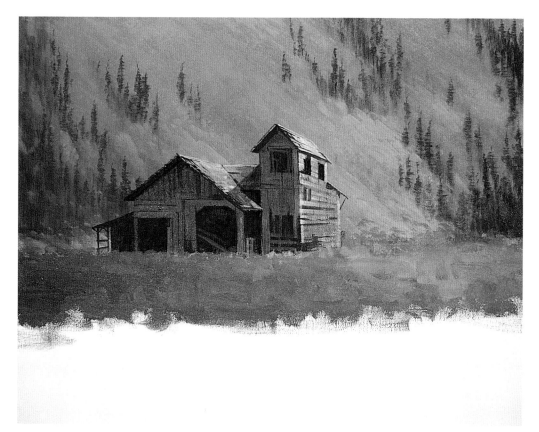

7 Underpaint Middle Ground

Suggest rough middle ground by mixing gesso with touches of Burnt Sienna, Dioxazine Purple and Ultramarine Blue. Blend these colors together on the canvas using short, choppy horizontal strokes with your no. 6 bristle brush. Don't overblend or you will end up with a solid gray tone. Allow brushstrokes to show in the finished work.

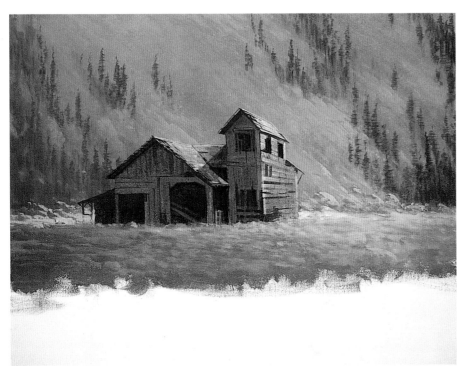

8 Highlight Middle Ground

Highlight the middle ground with the rough facade of dirt and rocks. Mix gesso with a touch of Cadmium Orange, Cadmium Yellow Light and water to make it creamy. This color can range from a light tan to a brighter gold. Scatter the highlights throughout the middle ground with short, choppy horizontal strokes using a no. 4 or no. 6 bristle brush. Show some of the underpainting to give the ground a three-dimensional appearance.

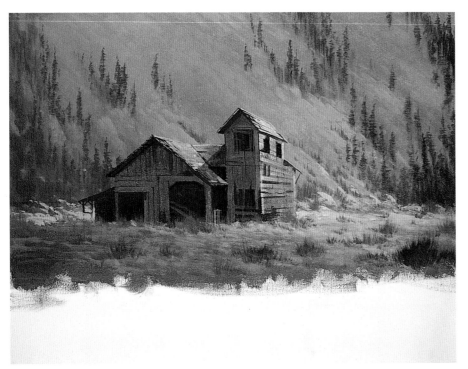

9 Paint Clumps of Grass in Middle Ground

Mix Hooker's Green Hue with a touch of Dioxazine Purple and gesso to make a grayish-green color. Drybrush in clumps of grass scattered throughout the middle ground using a no. 4 or no. 6 bristle brush. Make sure your mixture is not too dark. These clumps diffuse the horizontal format of the middle ground and add more interest. They shouldn't compete with anything.

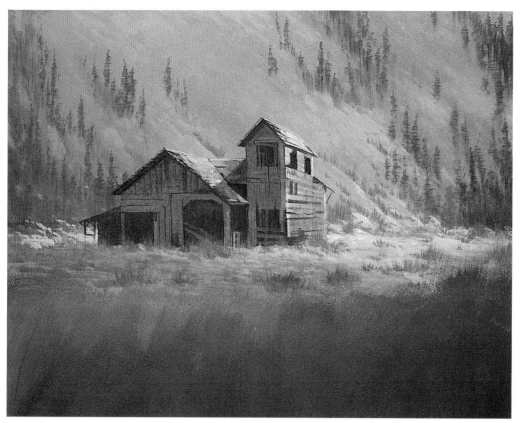

10 Underpaint Foreground Brush

Mix Hooker's Green Hue, Burnt Sienna and a touch of Dioxazine Purple on your palette. Make the mixture very creamy. Paint across the base of the canvas entirely using a hake brush. Use a vertical stroke beginning at the bottom of the canvas and pulling upward. Feather in a soft edge. Cover the canvas well. If it doesn't appear dark enough after the first layer dries, repeat this step one more time.

11 Brighten Middle Ground Highlights

Mix gesso with a touch of Cadmium Orange and Cadmium Yellow Light. Begin applying brighter highlights throughout the middle ground using a no. 4 flat sable brush. This emphasizes rugged ground. Add highlights at the mountain base behind the building, tying the background to the foreground. Don't over-highlight.

12 Detail Dark Weeds in Foreground

There are several time-consuming elements in adding all the taller dark weeds, so be patient. Mix Hooker's Green Hue, Dioxazine Purple and Burnt Sienna into a dark value. Thin it to an ink-like consistency. Fully load a no. 4 script brush and roll it around in the mixture until it comes to a point. Paint in a collection of taller dark weeds across the foreground. Paint the weeds at different heights, angles and densities. Add all you want—it is almost impossible to put in too many.

13 Accent Foreground With Toothbrush

This is one of my favorite steps because it is a great way to add color accents. Find an old toothbrush and pick three or four of your favorite bright colors. Thin each color to an ink-like consistency. Face the toothbrush toward the canvas and run your forefinger across the bristles to create small round splatters. Experiment with how close to hold the toothbrush to the canvas. Also experiment with the mixture consistency and how much of it to use. All these things affect the splatter concentration. Repeat these steps with the other colors.

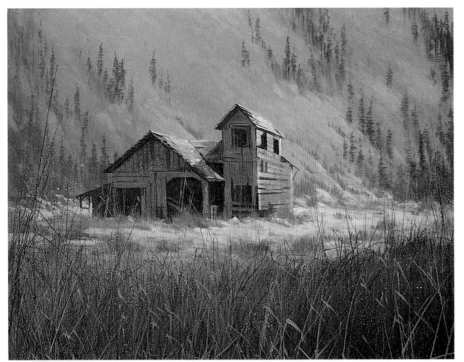

14 Detail Light Weeds in Foreground

This is identical to step 12, except with lighter colors. Mix Thalo Yellow-Green and a touch of Cadmium Orange and thin it to an ink-like consistency. Paint in a collection of lighter weeds using a no. 4 script liner brush. Change the color a little with touches of Hooker's Green Hue or a touch of Cadmium Yellow Light. Brush in several more light weeds. Paint a variety of shapes, heights and angles.

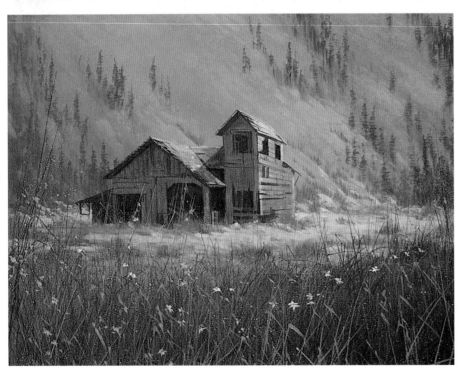

15 Final Foreground Details

Look at the entire foreground and decide if you need more dark weeds. If you do, add them with a no. 4 script liner brush. This is also a good time to add small wildflowers with a no. 4 round sable brush. Make them any color, just don't overpower the center of interest. Enhance with other accent colors. Have fun with your artistic license. Paint most of these highlights with smaller sable brushes, choosing the one that best fits the job.

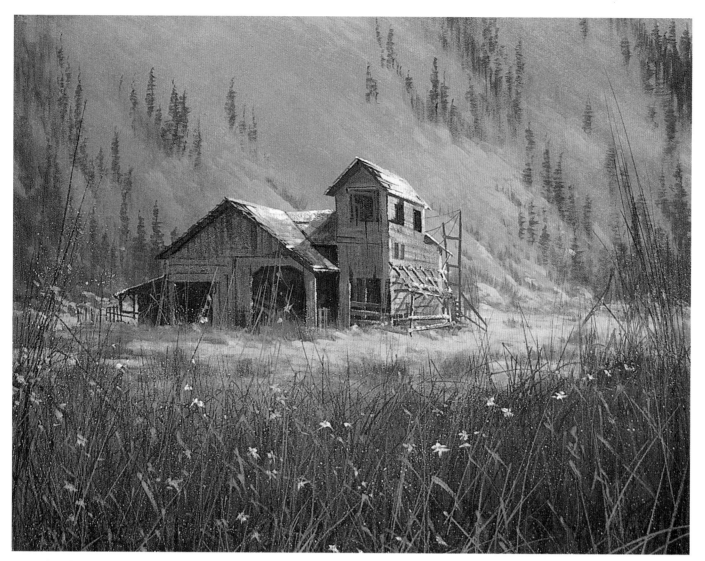

16 Add Final Details

Apply the details to the old building. Add other enhancements, for example, a few brighter highlights in the middle ground and mountain base. Highlight the building with a mixture of gesso and Cadmium Orange. Drybrush a few highlights on the light side of the building with a no. 4 flat sable brush. Add more gesso to the mixture and add a few brighter highlights on the roofs. Mix Ultramarine Blue and Burnt Sienna with a no. 4 script liner brush. Paint in a few more dark cracks and broken boards. Notice, I also added an old, broken lean-to shed and some old posts, fences and miscellaneous boards. These examples all enhance the interest of the building and aid composition. Have fun finishing up!

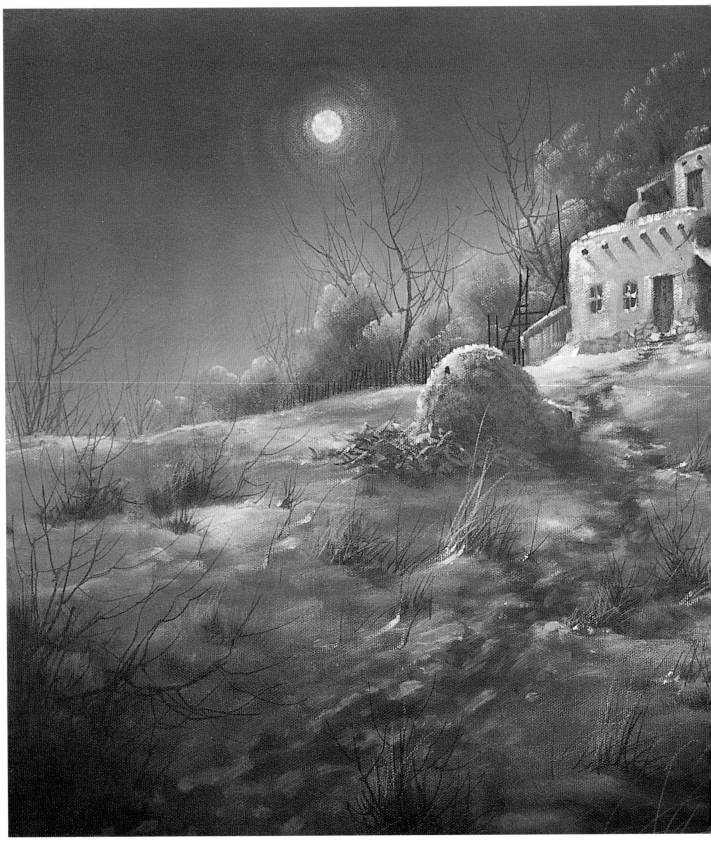

Moonlight Adobe
16" × 20" (41cm × 51cm)

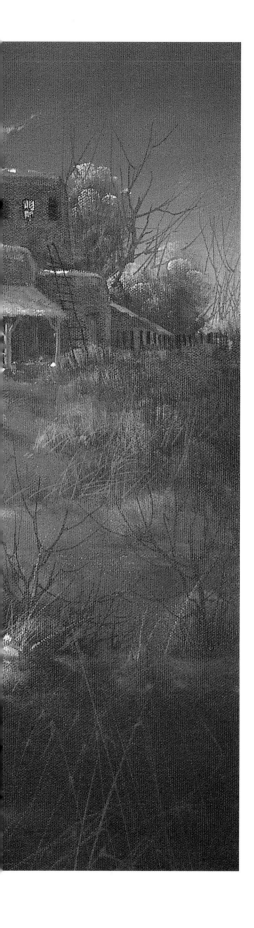

Moonlight Adobe

I thought it might be fun to find the perspective of something other than a traditional building. While living in New Mexico, I found old adobe buildings to be interesting studies. The adobe structures are fun to paint and they create unique perspective challenges. They are challenging because they are stacked on top of one another and they have lean-to sheds attached to them. In this study, the buildings are slightly elevated on a hill above the horizon line. This is a one-point perspective project in which you find the perspective of the left sides of the buildings. Create the mood of a cold winter night with a contrasting warm inviting glow coming through the windows. This is a fairly monochromatic painting, with numerous value changes you need to be aware of. Work mainly with cool colors, using color complements to create warm accents.

1 Paint Sky

Wet the canvas with water to start creating the night sky. Apply a liberal coat of gesso with touches of Cadmium Yellow Light and Cadmium Orange. Beginning at the base of the sky, blend about halfway up with a hake brush. Use large crisscross strokes. While this is still wet, heavily apply Ultramarine Blue, Burnt Sienna and a hint of Dioxazine Purple, making a fairly dark value. Rinse out your brush. Blend this color downward until you meet the light area. Rinse your brush again. Feather the sky together.

2 Paint Moon and Glow

When the sky is completely dry, mix gesso and a touch of Cadmium Yellow Light. Paint a round circle to create the moon, using a no. 4 flat bristle brush. Let dry. Drybrush in the glow around the moon using a hake brush and the same mixture you used for the moon. Use a circular motion. As you extend out from the moon, gradually decrease the pressure until the glow fades into the sky.

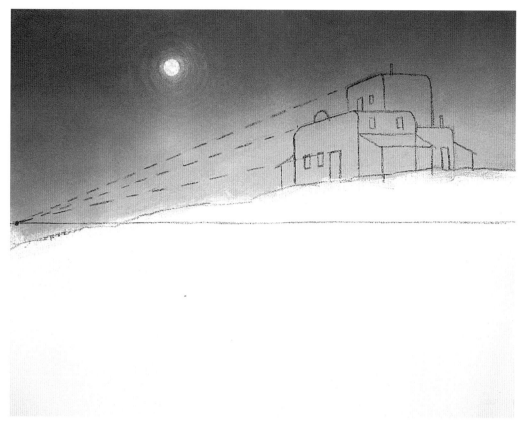

3 Find Perspective of Buildings

You can easily find the perspective of these buildings because they don't have peaked roofs. They are just square boxes stacked on top of one another, located on a hill above the horizon line. Place the horizon line. Sketch in the front of each building. Locate the vanishing point. Draw vanishing lines from the top corners of each building back to the vanishing point. Complete the procedure as described in the "Drawing One-Point Perspective" section (page 20).

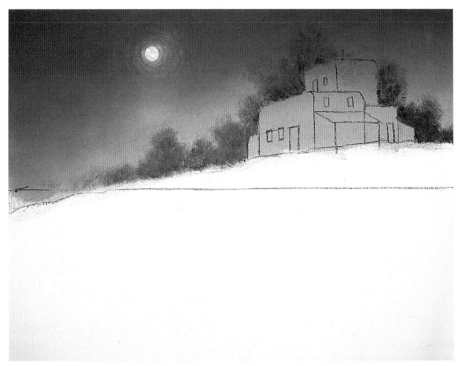

4 Underpaint Background Trees

These bushy trees are important to the painting. Mix Burnt Sienna with touches of Ultramarine Blue and Dioxazine Purple. Make this mixture on the warm side, not adding too much Ultramarine Blue. Lightly drybrush a balanced collection of trees using a no. 6 or no. 10 bristle brush and a small amount of paint. Leave interesting pockets of negative space to create good eye flow.

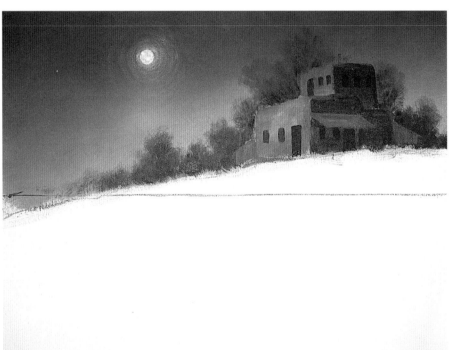

5 Underpaint buildings

Mix Burnt Sienna with a touch of Cadmium Yellow Light. I usually add a hint of Dioxazine Purple to give it a light gray tone. For the dark side of each building, add gesso to the mixture to soften the color. Block in this side with a no. 4 bristle brush. Add more gesso to the mixture. Block in the light side. These are old weathered buildings, so the corners should be slightly rounded with slightly rough edges. Darken the original mixture with Dioxazine Purple. Block in the doors and windows.

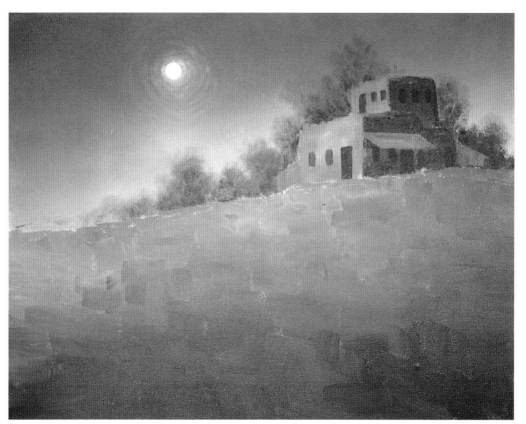

6 Underpaint Middle Ground and Foreground

Work out your artistic frustrations with this step. Apply gesso to the canvas with a no. 10 bristle brush. Add Ultramarine Blue, Burnt Sienna and touches of Dioxazine Purple. Mix all of these colors together as you paint large, broad brushstrokes across the canvas. Notice the color is not blended out very smoothly. Make your brushstrokes and tonal variations visible. This should be a cool tone, so don't use too much Burnt Sienna.

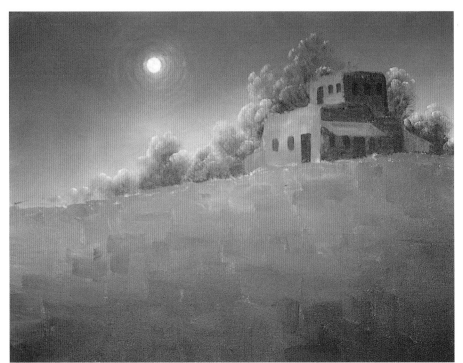

7 Highlight Background Trees

These background trees are easy to highlight. Mix gesso with touches of Cadmium Orange and Cadmium Yellow Light, making the texture creamy. Load a small amount onto the end of a no. 6 bristle brush. Carefully apply highlights with downward dry-brush strokes. Begin at the top of each clump and pull downward. Let the highlight fade into the darker paint. The top of each clump is the brightest area, so don't drag the highlights down too far.

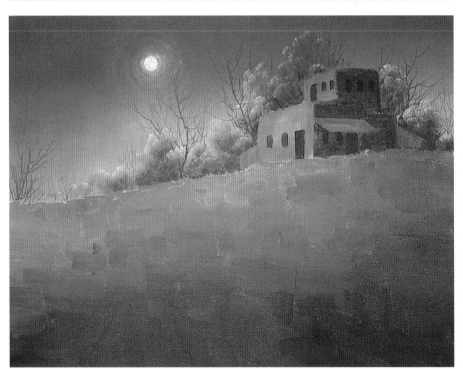

8 Paint In Dead Trees

Mix Burnt Sienna with touches of Ultramarine Blue and Dioxazine Purple. Add gesso to make it about the same value as the bushy trees. Thin the mixture to an ink-like consistency. Roll a no. 4 script liner brush in the mixture until the brush comes to a point. Paint in a collection of dead trees. Scatter them throughout the background.

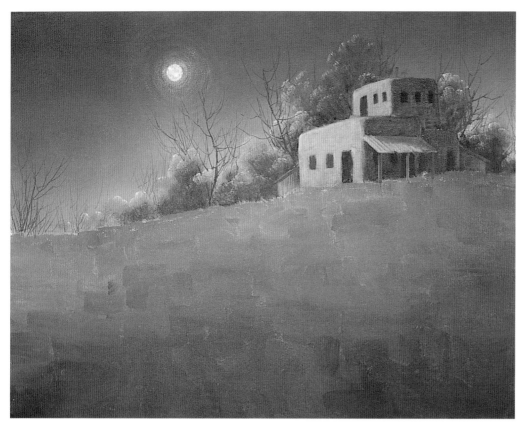

9 Adjust and Highlight Adobe

Mix a highlight color of gesso with a little bit of Cadmium Yellow Light and Cadmium Orange to a creamy consistency. Drybrush this highlight using a scumbling stroke with a no. 4 flat bristle brush. Simply square things up so the outer edges of the building are fairly vertical. Go over this highlight one or two times, making it as bright as you want. Adobe is not smooth, so don't blend all the brushstrokes.

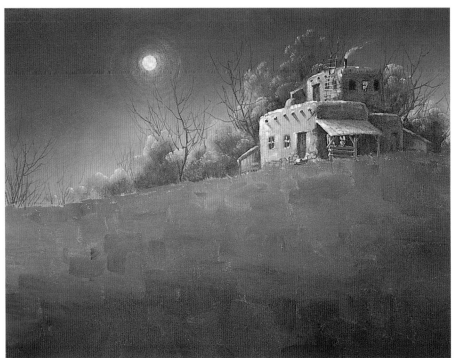

10 Detail Adobe

Use your artistic license here to add character to the buildings. Adjust the color value on whichever side of the building you are working. Add window lights using Cadmium Yellow Light and Cadmium Orange. Add Ultramarine Blue doors, wooden ladders, chimney smoke and touches of snow on top of the buildings. Also try adobe brick work at the base of the building. Its detail enhances the painting. The no. 4 flat and round sable brushes work best for most of the details. A no. 4 script liner brush works well for the finer details.

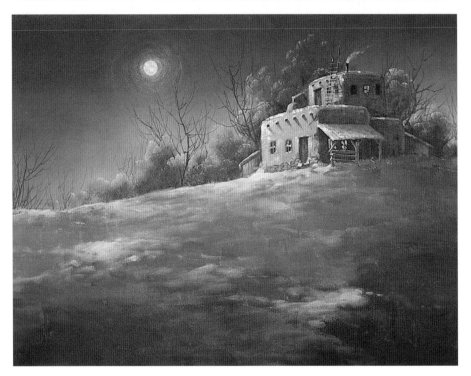

11 Contour Snow

The contouring establishes the hillside and creates depressions in the snow. You will add the clumps of grass in the depressions in step 13. Mix gesso with a touch of Cadmium Orange to a very creamy consistency. Scrub in these intermediate contour highlights with a no. 10 bristle brush. Blend the highlight with no hard edges, to help the snow look soft and drifty.

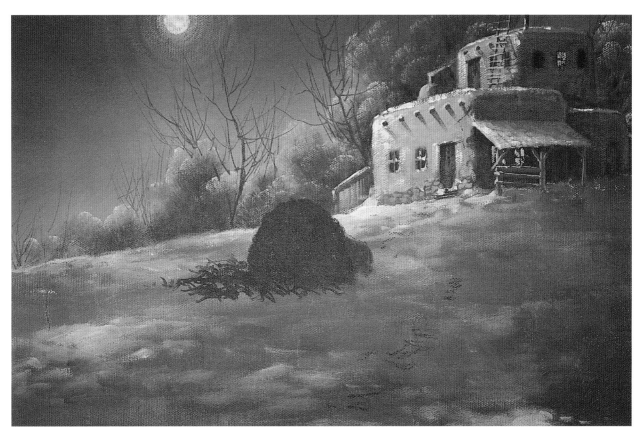

12 Underpaint Adobe Oven

Mix Burnt Sienna with a touch of Dioxazine Purple and Cadmium Yellow Light. Block in the oven with a no. 6 bristle brush. Paint it on fairly thick using a scumbling stroke—you want the texture to be rough. Use the same dark mixture to paint the pile of firewood at the base with a no. 4 round sable brush. Paint in a collection of small sticks—you will highlight them later.

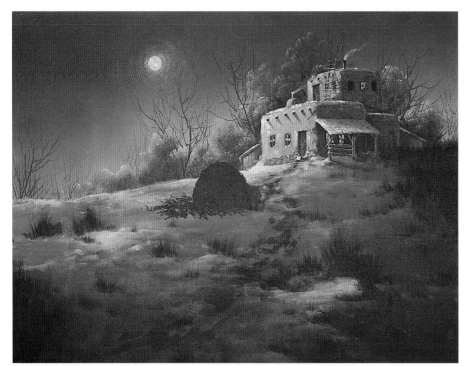

13 Underpaint Clumps of Grass and Pathway

Start with the clumps of grass by mixing Burnt Sienna with a touch of Dioxazine Purple. Make the mixture very creamy. Block in the clumps throughout the middle ground and foreground using an upward dry-brush stroke with a no. 6 bristle brush. Use interesting negative space and vary the clump size. Add a touch of Ultramarine Blue and Dioxazine Purple to the grass mixture to paint the pathway. Smudge footprints in the snow with a no. 6 bristle brush. Smooth any hard edges.

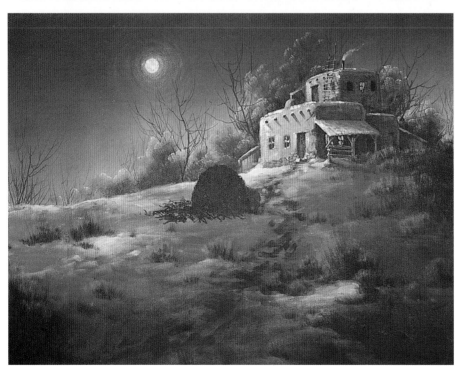

14 Highlight Clumps of Grass

Highlighting the grass is not much different from highlighting the background trees. Mix gesso with a touch of Cadmium Orange. This time, you want the orange to be more intense. Now load a small amount on the end of your no. 6 bristle brush, and using a downward dry-brush stroke, highlight the tips of these clumps of grass. Notice how soft these highlights are, so be careful to avoid any hard lines or edges.

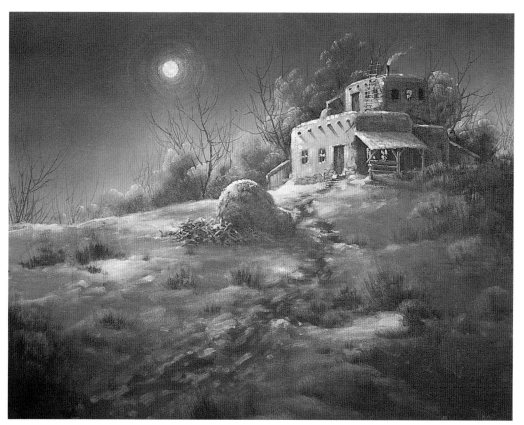

15 Highlight Snow

Mix gesso with touches of Ultramarine Blue and Dioxazine Purple, creating a soft bluish-purple with a no. 4 bristle brush. This is the shadow color on the snow. Apply this color to the shadowed side of the adobe oven, the woodpile, adobe building and a few areas throughout the middle ground. Now, mix gesso with a touch of Cadmium Orange. Paint this highlight with a no. 4 bristle brush in areas where you want the snow to appear drifted—for example, against the buildings, clumps of grass, adobe oven and around the footprints. Keep the highlights soft.

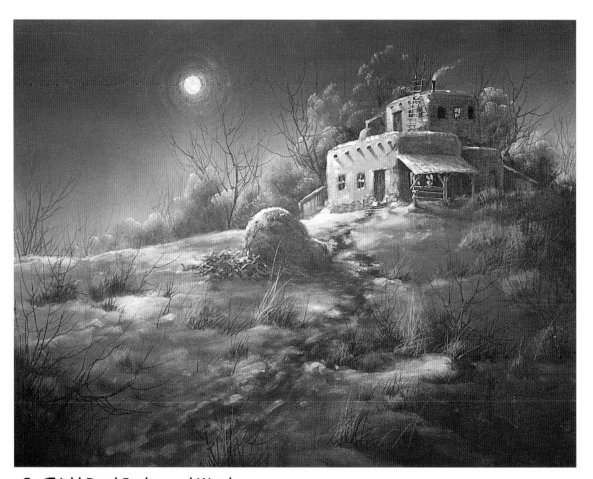

16 Add Dead Bushes and Weeds

Mix Ultramarine Blue and Burnt Sienna into an ink-like consistency using a no. 4 script liner brush. Scatter the darker weeds and dead bushes throughout the middle ground and foreground. Remember, these dead bushes are eye-stoppers, so size them big enough to do their job, especially in the left corner. Mix gesso and Cadmium Orange. Also paint in the lightly-colored weeds throughout the middle ground and foreground. Make some fairly tall.

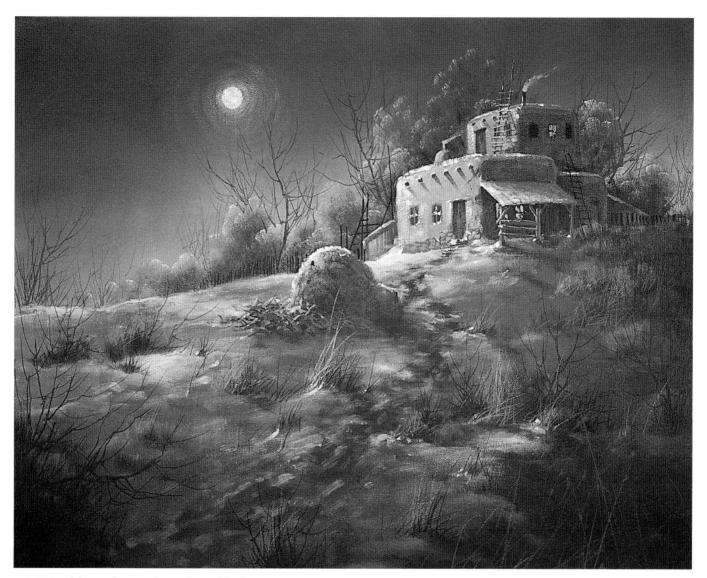

17 Add Final Details and Highlights

You can finish this painting in a variety of ways. For example, add accent highlights in Pure White to the peak areas on top of the adobe oven, along the roof edges, up against some of the weeds and anywhere else a highlight adds to the moonlight glow. Add flowers and tall poles behind the adobe building. Paint an additional ladder and scatter a few more accent highlights. Don't overdo it—when you're done, you're done!

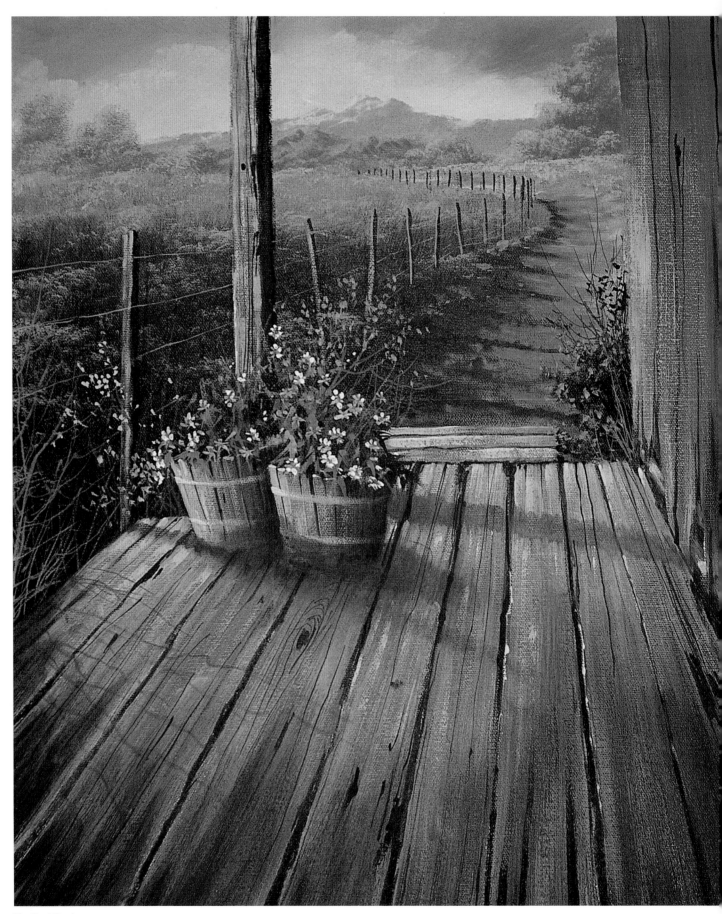

The Front Porch
20" × 16" (51cm × 41cm)

The Front Porch

Perspective works well and is necessary for other types of paintings than those with complete structures. For example, in still lifes, you may need to find the perspective of a tabletop, floor or in this case, a wooden front porch. Even though it looks difficult, this is an easy perspective problem to solve. You are only finding the perspective of the corner and top of the porch as opposed to creating an entire structure with walls, roofs, doors, windows and so on. This composition also offers the opportunity to paint old weathered wood and other fine details. It gives an interesting view of the landscape. Instead of looking at the building from a distance, you are standing on the front porch looking out at the landscape. The soft setting is a true complement to the old weathered wood. Have fun!

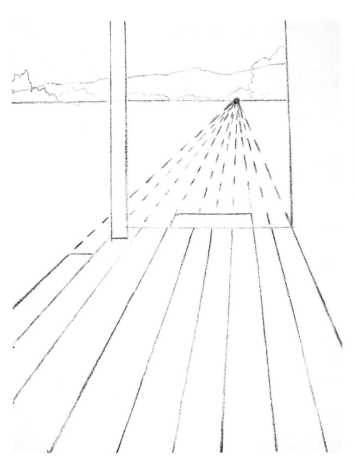

1 Find Perspective of Porch

This project proves the usefulness and importance of one-point perspective to the landscape painter. First, locate the horizon line. Draw in the front of the porch using no. 2 soft vine charcoal. Decide the porch width. Place dots the distance apart that you want the boards. Locate your vanishing point anywhere on the horizon line, depending on the angle you want the boards to have. Draw a vanishing line from each dot back to the vanishing point.

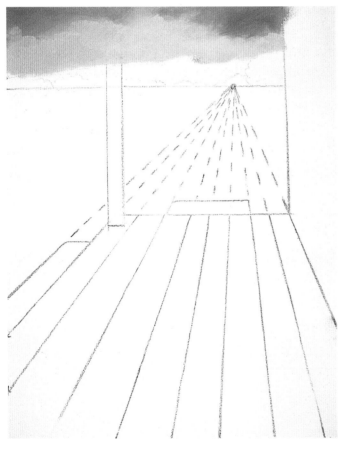

2 Paint Sky

Lightly wet the sky. Apply a liberal coat of gesso with a no. 10 bristle brush. While it is still wet, add Cadmium Yellow Light at the base. Blend upward, all the way to the top. While this is still wet, blend Ultramarine Blue across the top of the sky. Begin blending downward using a variety of strokes to create the suggestion of clouds. This is similar to a wet-into-wet oil technique. Be careful not to overblend because your sky will turn one color and you will lose your cloud formations.

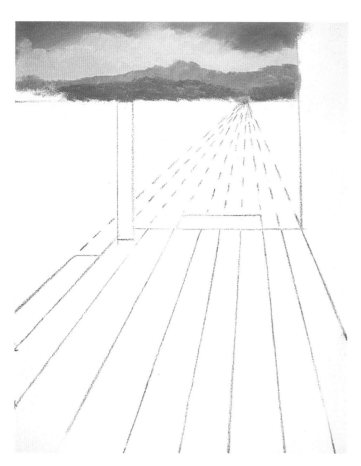

3 Paint Background Hills

Mix gesso with touches of Dioxazine Purple, Ultramarine Blue and Burnt Sienna. The value should be more purple and not too dark. Block in the first range of hills with a no. 4 or no. 6 bristle brush. Slightly darken the mixture with a little more Ultramarine Blue, Dioxazine Purple and Burnt Sienna. Block in the second layer. This value is only slightly darker than the first layer. Be sure both layers have interesting shapes.

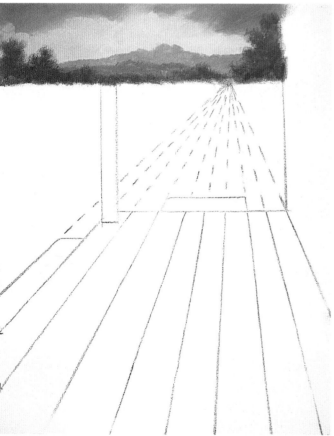

4 Paint Background Trees

This is a fairly easy step. Mix gesso with Dioxazine Purple and touches of Ultramarine Blue and Burnt Sienna. This is slightly darker than the last layer of the background. Make the mixture fairly creamy. Brush in a variety of distant trees across the horizon with a no. 6 bristle brush. The largest trees on the sides of the painting act as eye-stoppers.

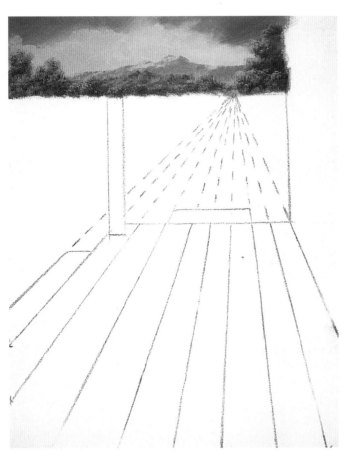

5 Highlight Background Hills and Trees

Mix gesso with a touch of Cadmium Orange. Carefully paint in some simple highlights with a no. 4 flat sable brush. Allow some of the background to come through to help create a rugged texture and more of a three-dimensional form. Add a little more Cadmium Orange to the mixture and repeat the process for the second range of hills. Mix gesso with Thalo Yellow-Green and a slight touch of Cadmium Orange. Highlight the top and outer edge of the trees with a no. 6 bristle brush. Leave plenty of dark pockets of negative space.

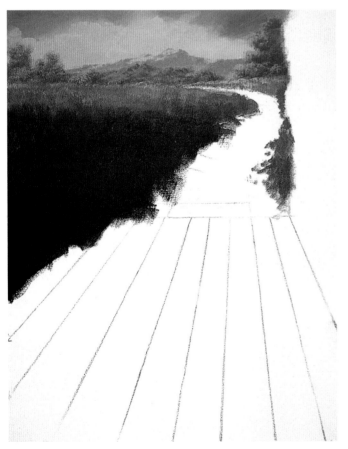

6 Underpaint Middle Ground Meadow

This step is really fun. Begin at the top of the hill by applying Cadmium Yellow Light, Thalo Yellow-Green and touches of Cadmium Orange with a no. 10 bristle brush. Paint on these colors very thick. Slightly blend them together. While the paint is still wet, lay your brush flat against the canvas and push up. This creates a grassy texture. Continue to come forward with these colors in 2-inch (5cm) sections. Every time you move toward the foreground, add more Hooker's Green Hue and Burnt Sienna to darken the mixture. Push up these colors and then move to the next section. Finally add Dioxazine Purple to darken the mixture for the foreground.

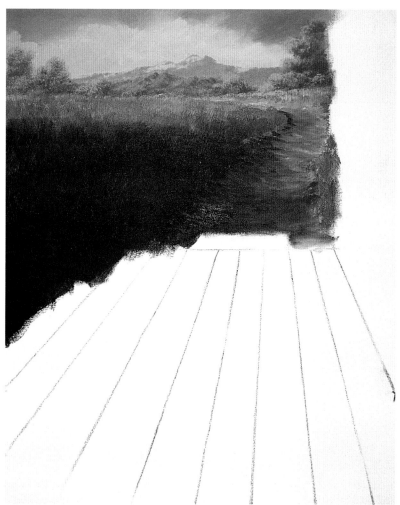

7 Underpaint Pathway

This pathway is easy to underpaint. Mix Cadmium Orange and gesso. Starting at the back of the pathway, cover the area with short, choppy horizontal strokes using a no. 6 bristle brush. As you come forward, begin adding touches of Burnt Sienna. Since the left side of the road is shadowed, use Burnt Sienna with a small amount of Dioxazine Purple to darken it. Use short comma strokes, and then gradually blend out into the middle of the sunlit part of the path. The outcome is a dark, middle and light value.

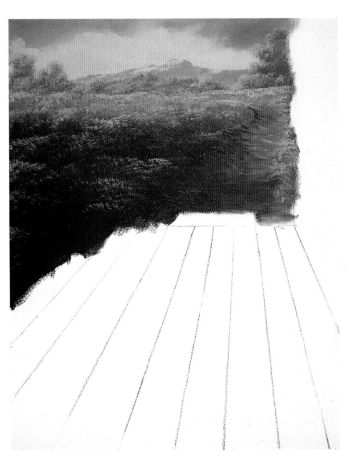

8 Highlight Middle Ground Meadow

Mix Cadmium Yellow Light and a touch of Thalo Yellow-Green. Add gesso for the highlight at the very top of the hill. Make the mixture creamy. Beginning at the top of the hillside, lightly paint the highlights in an umbrella-like pattern with a no. 10 bristle brush. The idea is to define the shape of the hillside while giving it a spring-like feel. As you come forward, don't hesitate to change the color by adding more Cadmium Yellow Light, or Thalo Yellow-Green—even a touch of Cadmium Orange. Don't make the highlight too solid, or you will lose the contour of the meadow caused by the visible pockets of negative space.

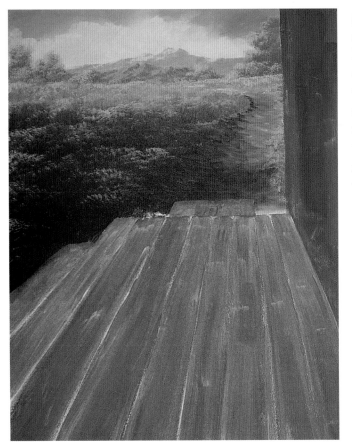

9 Underpaint Porch

This step takes a little while, but it is not hard to do. Mix the colors on the canvas as you go to get a variety of tones, or mix the color on your palette. Mix gesso with Burnt Sienna, Ultramarine Blue and a slight touch of Dioxazine Purple, making a fairly true gray. If you mix on the canvas, just mix as you go. Whichever way you choose, be sure the paint is fairly creamy. Block this in with a no. 10 bristle brush. Follow the direction of the porch boards so you don't lose the perspective.

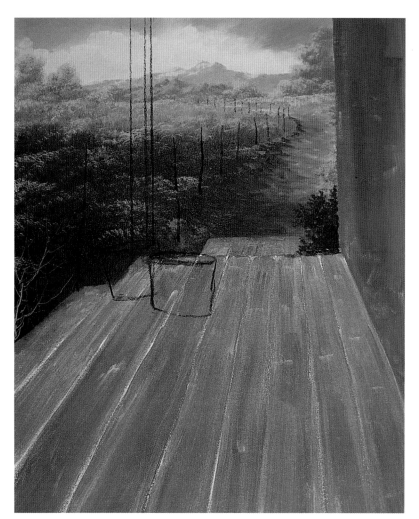

10 Sketch Post, Fence, Buckets and Miscellaneous Bushes

Sketch miscellaneous objects into your painting with your no. 2 soft vine charcoal. It's better to work out any composition problems that you might run into by adding these early on. One potential problem is if you sketch in one object at a time and paint it, you could find out as you paint in the others that you are not pleased with the composition. Then you would have to paint out the objects and start over. Pre-sketching and arranging the objects saves you a lot of extra work later.

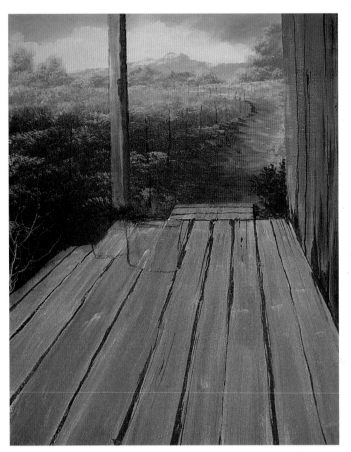

11 Detail Porch with Cracks and Crevices

Block in the boards with a medium gray tone similar to the porch. Mix Burnt Sienna, Ultramarine Blue and some gesso. Block in the shadowed side first. Then lighten the mixture with gesso and block in the sunlit side with a no. 4 bristle brush. Thin the original dark mixture to an ink-like consistency. Begin painting in cracks, holes and crevices with a no. 4 script liner brush. Be careful, this is a lot of fun and it's easy to get carried away.

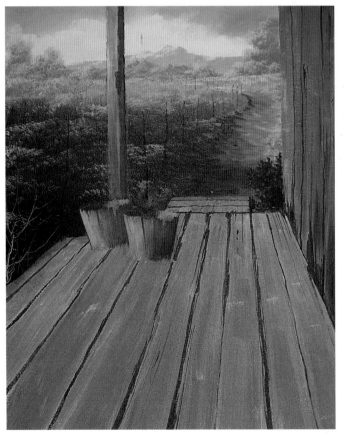

12 Underpaint Buckets

Create a dark, middle and light value in this step. These values give the buckets a three-dimensional form. Mix Burnt Sienna, Ultramarine Blue, a touch of Dioxazine Purple and a little gesso. Begin underpainting the dark side of the buckets. Use vertical strokes with a no. 4 flat sable brush. Add a little more gesso as you paint across to the middle, to create the middle value. Add more gesso to create the light value. Add a touch of Cadmium Orange to warm up the lightest value. Paint the inside of the buckets with the fairly dark value. The flowers you add later will cover most of the inside.

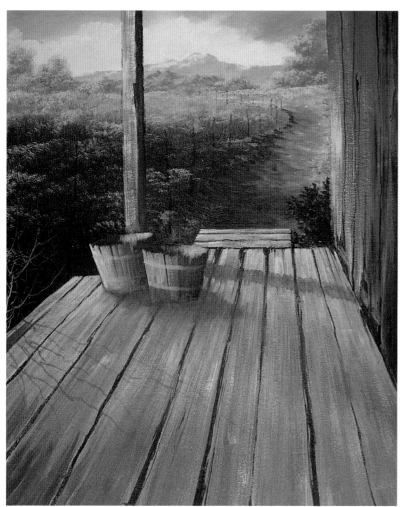

13 Highlight Porch and Buckets

The secret of this step is to drybrush a lot. Begin with either the porch or the buckets. Mix a highlight color of gesso with a touch of Cadmium Orange. Use any of the smaller flat, sable or bristle brushes. Begin lightly drybrushing over the gray underpainting. This not only highlights the color, but also suggests weathered wood. Drybrush these areas two or three times to achieve your desired brightness.

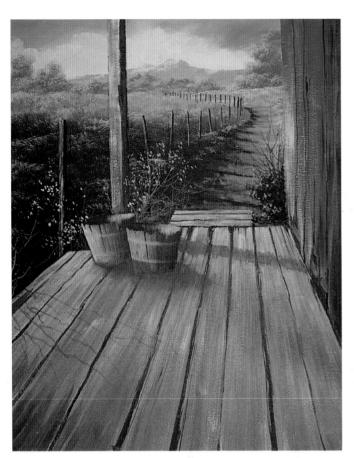

14 Detail Background
First paint the fence. Create a brownish-gray mixture of Burnt Sienna and a touch of Ultramarine Blue. Add just enough gesso to soften the hue. Block in the fence posts with a no. 4 round sable brush. Highlight the posts with a bright mixture of gesso and a touch of Cadmium Orange. Highlight the sunlit side of the path using the same color with a no. 4 flat sable brush. Mix Hooker's Green Hue, Burnt Sienna and a touch of Dioxazine Purple. Paint in the bushes on the back of the porch with a no. 6 bristle brush. Now, have fun adding little touches—for example, use touches of Cadmium Yellow Light to suggest flowers or add tall weeds using Thalo Yellow-Green. Add highlights around the back of the porch with the Cadmium Orange and gesso mixture.

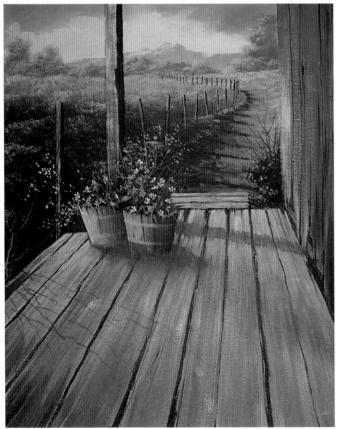

15 Paint Flowers in Buckets
Start this step with a dark background. Mix Hooker's Green Hue with Ultramarine Blue and Dioxazine Purple. Block in an irregularly shaped background, suggesting leaves and stems with a no. 4 flat sable brush. Paint the flowers with Pure White using your no. 4 round sable brush. Scrub in a nice collection of small white flowers. They don't need to be detailed, just suggested. Add some Cadmium Orange centers to finish them. Don't hesitate to enhance them with leaves or highlights.

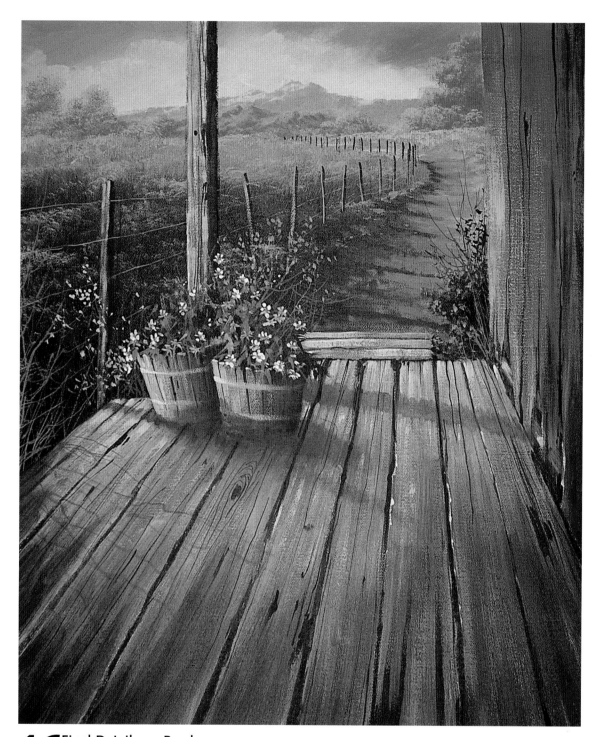

16 Final Details on Porch

Scan the painting—specifically the porch area—for things that you could add to improve the composition, values or color scheme. For example, add more detail to the wood, such as cracks, wood grain and broken spots. Intensify the highlights. Specifically focus on the cast shadows. Mix Dioxazine Purple with a slight touch of Burnt Sienna and a little gesso. Drybrush the shadows of the post and buckets with a no. 4 flat sable brush. Make soft edges. Switch to the no. 4 round sable brush and paint the shadows cast from the limbs outside the porch.

I just have some final comments to make. First, I have purposely left the painting slightly unfinished for you to add other objects such as a barn or farmhouse in the distance. You could also highlight the meadow, paint a cat curled up on the porch, scatter some flower petals and leaves that have fallen from the bucket, or even add an old rocking chair on the porch. The sky is the limit here, so use your artistic license and have fun.

Index

A

Accenting. *See* Highlighting
Acrylic paint. *See* Colors, mixing; Paint
Adobe, 107-9
Angles, 21, 23, 28
 of roof, 49-50, 77

B

Background, 90, 124
Bank, underpainting, 80
Barn, 75, 77-8, 86
Birds, 47, 58, 73
Blocking in. *See* Underpainting
Boards, weathered, 43, 79, 99, 115, 122, 124-5
 planks, 31
Boat dock, 23
Bricks, 29
Brush, underpainting, 95
Brushes, 11-12
Buckets, 121-3
Buildings, 32-4, 61, 89
 adobe, 101, 104, 107-8, 111
 details , 92, 99
 perspective of, 26-7, 65, 91, 103
 underpainting, 65, 92, 104
Bushes, 57, 87, 89, 95, 121
 dead, 47, 58, 112

C

Canvas, 11, 16
Charcoal pencil, 11
Charcoal, soft vine, 11, 17, 76, 116.
 See also Sketching
Chimneys, 29-30, 49
Clouds, 39, 51, 62, 116
Color complements, 8, 11, 101
Colors, mixing, 9-11
 black, 11

dark gray, 46
earth tone, 11
flesh tone, 11
gray, 39, 43, 65
gray-green, 40
highlights, 41, 64, 86, 91, 94, 111, 125
rocks, 54
sky, 38, 50, 62, 102
sunshine, 44, 46, 56
trees, 90
Contrast, 75
Country Peace, 36-7

D

Dabbing, 8
Depth, 39, 54
Details, 46-7, 68, 79, 86, 92, 108, 122
of adobe, 108
background, 124
of building, 92
final, 72, 87, 98-9,113, 124-5
foreground, 89, 98
of house, 43, 47, 52, 58
landscape, 47, 58
of porch, 122
of weeds, 96, 98
Dirt, 94
Doors, 28, 30, 34, 43, 49, 52, 65, 78, 91,103, 108,115
Double load, 8
Drybrush, 8, 11, 43, 45, 55-6, 63, 68, 72, 83, 85, 91-2, 94, 102, 107, 110, 123

E

Easel, 11, 16
Eraser, 18
Evening Shadows, 60-61
Eye flow, 8, 54, 90
Eye-stoppers, 8, 47, 58, 112, 117

F

Farmhouse. *See* House
Feathering, 8, 102
Fence, 35, 99, 121, 124. *See also* Fence posts
Fence posts, 58, 70-1, 86, 99, 121, 124. *See also* Fence
Firewood, 109
Floor, 22-3, 31, 115
Flowers, 47, 58, 69, 73, 98,113, 122, 124
Footprints, 110-11
Front Porch, The, 114-15

G

Gesso, 8-9, 11
Glaze, 9
Grass, 56, 83, 89, 94
 highlighting, 45, 69, 85,110
 underpainting, 44, 66, 110

H

Highlighting, 9, 40-41, 46-7, 59, 73, 82, 87, 91, 94, 96-9, 107, 110-11, 113, 124. *See also* under individual entries; Sunlight
 brightening, 96
 using toothbrush, 97
Hills, 39. *See also* Mountains
 background, 63, 117-18
 highlighting, 40, 57, 63, 91
 underpainting, 53, 63
Hilltop Retreat, 48-9
Horizon, 28-30, 32-5, 75, 91, 101
 perspective above, 25, 49-50
 perspective below, 26
Horizon line, 18, 23-4, 27, 38, 49-50, 77, 81, 91, 116
House, 34, 36-8, 42, 48-9
 details of, 43, 47, 52, 58

highlighting, 58, 68
perspective of, 28-30
underpainting, 43, 52

I

In Need of Repair, 74-5

L

Ladders, 108
Landscape, 58, 62, 75-6, 115
Leaves, 45, 124
Lighting, 16
Lost in Time, 88-89

M

Materials, 11
Meadow, 41, 118, 120
Moon, 102
Moonlight, 113
Moonlight Adobe, 6-7, 100-101
Mountains, 39-40, 89-90. *See also* Hills

N

Negative space, 9, 45, 54, 63-4, 78, 90, 118, 120

O

Oven, adobe, 109, 111

P

Paint, 11
Palette, 11, 13-15
Palette knife, 11, 17
Parallel lines, 18-19, 28-30, 33
Path, 110, 119
Pebbles, 46, 68
Perspective, 7, 18, 24, 27, 30-31, 50, 70, 77, 116
of building, 26-7, 65, 91, 103
above horizon, 25, 49-50
below horizon, 26
of house, 28-9
one-point, 7, 18-20, 37, 49, 61, 101, 116
two-point, 7, 18-19, 32-5, 75, 81
Photo, drawing from, 30, 37

Porch, 23, 28-30, 34, 115-16, 120, 122-3
Posts. *See* Fence posts
Proportion, 7

R

Road, 42, 44, 66-7
Rocks, 46, 56, 94
highlighting, 55-6, 68
underpainting, 54
Roof, 28, 30, 34, 43, 91, 115

S

Scrubbing, 10, 39-41, 51, 76, 82
Scumbling, 10, 107
Shadows, 43, 52, 61, 66, 72, 75, 119, 124-5
Sheds, 49, 99
Shingles, 29-30, 43
Sidewalk, 34
Siding, 29-30
Sketching, 18, 38, 42, 50, 62, 76, 86, 121
Sky, 38, 50, 62, 76, 102, 116
Smoke, 108
Snow, 75, 80, 84, 108
highlighting, 82, 111
Spray bottle, 11, 13-15, 17
Sta-Wet palette, 11, 13-15
Steps, 23, 29, 34
Sticks, 109, 111
Still life, 31, 115
Sunlight, 52, 56, 69, 119, 124. *See also* Highlighting
Sunset, 61

T

Tabletop, 22, 31, 115
Tank, 82
Texture, 53, 75, 80, 118
The Front Porch, 114-15
Toothbrush, 97
Tree limbs, 54, 70, 73, 77, 89
Tree trunks, 42
Trees, 70
background, 40-41, 51, 64, 77, 103, 106, 117-18

cedar, 78
dead, 106
highlighting, 41, 64, 106
pine, 90-91
underpainting, 40, 104
Triple load, 8

U

Underpainting, 10, 76, 90, 93, 95, 105. *See also* under individual entries

V

Values, 10, 41, 53, 66, 75, 82, 90, 92, 108, 117, 119, 122
Vanishing line, 18, 21, 24-35, 70, 103, 116
Vanishing point, 18-21, 24, 26-35, 37-8, 50, 61, 65, 70, 77, 81, 91, 103, 116
placement of, 22-3
Vantage point, 49
Varnish, 11

W

Wash, 9
Weeds, 47, 59, 72-3, 87, 89, 96, 98, 112, 124
Wet-on-dry, 10
Wet-on-wet, 10, 116
Wildflowers. *See* Flowers
Windmill, 35, 75, 81-2, 86
Windows, 28, 30, 34, 43, 49, 52, 65, 78, 91, 103, 108, 115
Wire, 58
Wood, weathered. *See* Boards
Woodpile, 109, 111

Y

Yard stick, 18

Get Creative with North Light Books!

Learn techniques of perspective that will help your creativity: no T-squares, complicated equations or mechanical terms, just simple instructions and hands-on exercises to teach you how to create a sense of depth in your drawings and paintings.

ISBN 0-89134-446-2, PAPERBACK, 144 PAGES, #30386-K

Now you can paint the intimate, mysterious and secret world of nature—full of life, drama and beauty. Learn how to develop your ideas and create stunning compositions.

ISBN 1-58180-457-1, PAPERBACK, 128 PAGES, #32709-K

In this book, the first in the Paint Along with Jerry Yarnell series, Jerry provides you with ten beautiful landscape projects, including a beautiful snow-covered country road, a secluded forest path, a glorious desert, a quiet lakeside church and more.

ISBN 1-58180-036-3, PAPERBACK, 128 PAGES, #31592-K

Learn how to properly execute basic acrylic painting techniques—stippling, blending, glazing, masking or wet-in-wet—and get great results every time.

ISBN 1-58180-042-8, HARDCOVER, 128 PAGES, #31896-K

Claudia Nice introduces you to the joys of keeping a sketchbook journal, along with advice and encouragement for keeping your own.

ISBN 1-58180-044-4, HARDCOVER, 128 PAGES, #31912-K

Painting inspirations. There's no better way to describe the 10 stunning projects you will master, provided by Jerry Yarnell in Volume Two of his popular series.

ISBN 1-58180-100-9, PAPERBACK, 128 PAGES, #31781-K

Here's the reference you've been waiting for! You'll find 28 step-by-step demonstrations that showcase the methods that can help you master the many faces of acrylic painting.

ISBN 1-58180-175-0, PAPERBACK, 128 PAGES, #31935-K

Step-by-step mini-demos in acrylics show you how to paint the surprisingly intricate and beautiful world of butterflies, insects, hummingbirds and more!

ISBN 1-58180-162-9, HARDCOVER, 144 PAGES, #31911-K

These books and other fine North Light titles are available from your local art & craft retailer, bookstore or online supplier or by calling 1-800-448-0915.